PHOEBE ANNA TRAQUAIR

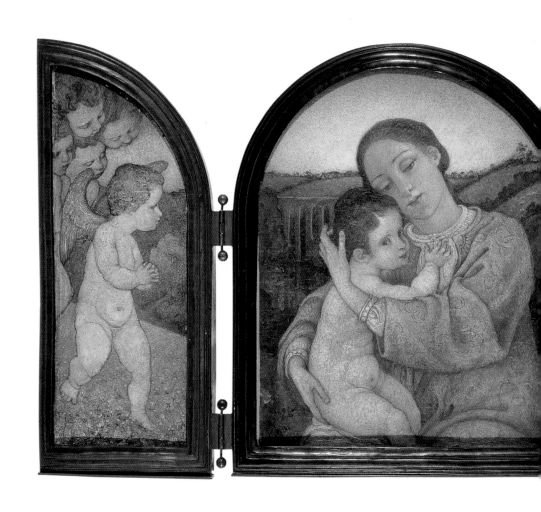

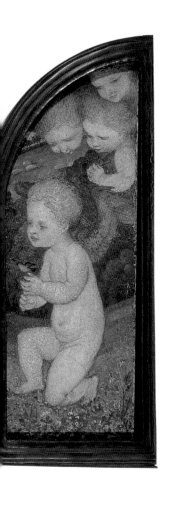

Elizabeth Cumming

Phoebe Anna Traquair
1852–1936

National Galleries of Scotland
in association with
National Museums Scotland
Edinburgh · 2011

First published by the Trustees of the
National Galleries of Scotland in
association with NMS Publishing –
a division of NMS Enterprises Limited, 2005.

Reprinted with revisions 2011.
© Elizabeth Cumming 2005

Designed and typeset in Octavian
and Shaker by Dalrymple
Colour reproduction by Inglis Allen
Printed in Poland by Perfekt

ISBN 1 903278 65 1

Cover: Detail from *The Progress
of the Soul: The Victory*, 1902
(Scottish National Gallery, Edinburgh)

Frontispiece: Triptych: *Motherhood*, 1901
(Scottish National Gallery, Edinburgh)

Contents

Acknowledgements

The author would like to express her gratitude to the many individuals who have made this book possible. The Traquair family graciously allowed the artist's own words to be used and key images to be reproduced to achieve a balanced overview. Her letters to Percy E. Nobbs are quoted by kind permission of his family. Letters from Phoebe Anna Traquair to her nephew William E. Moss are quoted by kind permission of the Trustees of the National Library of Scotland. Excerpts from the Lorimer papers are published by permission of Edinburgh University Library Special Collections. Warmest thanks are due to these institutions and all other owners of manuscripts, objects and buildings here illustrated: without their support this would have been a sorry book. For recent discussion, information, and understanding of Traquair's work, the author is particularly indebted to Fiona Allardyce, Nicola Gordon Bowe, Margaret Campbell, Pam Cranston, George Dalgleish, Godfrey Evans, Odile Hughson, Amy Lawch, Margaret Langdell, Kate Love, Rosemary Mann, Roberta Paton and Geoffrey Scheurman. Many others have helped over the years. At NGS Publishing Janis Adams, Christine Thompson and David Simpson have been totally committed to the book, and their support and enthusiasm is appreciated. Murray Simpson and Duncan Thomson also read the manuscript and made useful suggestions. As keeper of the Scottish National Portrait Gallery, Duncan first presented Traquair's work to an astonished public at the 1993 Edinburgh International Festival. As the current Chair of the Mansfield Traquair Trust he has also directed the recent operation to save 'Edinburgh's Sistine Chapel', the former Catholic Apostolic Church. Architect Stewart Brown has also given time and energy far beyond the call of duty to the care of this building. Lastly, the designer Robert Dalrymple, with his usual commitment to the highest quality, has turned a short, ordinary text into a 'book beautiful'.

ELIZABETH CUMMING

Foreword

The artistic versatility of Phoebe Anna Traquair continues to astonish the ever-increasing number of those familiar with her work. Not the least part of her interest is the fact that, as a woman artist, who was essentially the product of Victorian society, she was able to achieve so much while, at the same time, pursuing a conventional domestic life which included the rearing of three children.

Her fame was considerable in the latter years of the nineteenth century and during the early part of the twentieth century, when the range of her work in painting, mural decoration, jewellery, bookbinding and embroidery was admired by figures as diverse as John Ruskin and W. B. Yeats. This reputation was eclipsed for a time, almost inevitably, by the modernist movement, but her virtues shone out once more and she was seen to be an important figure in the Arts and Crafts movement. In recent years, another measure of this burgeoning reputation has been the interest shown in the restoration of the great mural cycle painted between 1893 and 1901 in the former Catholic Apostolic Church (now the Mansfield Traquair Centre) in Edinburgh, a project completed in 2005.

It is a particular pleasure that this book has been co-published with National Museums Scotland, which is the direct descendant of the institution responsible for Phoebe Traquair's presence in Edinburgh in the first place. She was she was married to Ramsay Heatley Traquair, the first keeper of the Natural History collections of the Edinburgh Museum of Science and Art. National Museums Scotland now has the largest collection of decorative arts by Phoebe Traquair in public hands, and was a major lender to Elizabeth Cumming's seminal exhibition, held at the Scottish National Portrait Gallery in 1993, which brought Phoebe Traquair to a deservedly wider audience. Dr Cumming's dedicated research using the wide-ranging collections of the National Galleries of Scotland and National Museums Scotland has provided a unique insight into the extraordinarily varied skills of this prolific artist.

JOHN LEIGHTON
Director-General, National Galleries of Scotland

DR GORDON RINTOUL
Director, National Museums Scotland

Introduction

In January 1904 a quartet of remarkable embroideries left the Edinburgh home of their designer and maker Phoebe Anna Traquair (1852–1936) for America, to be shown in the Louisiana Purchase Exposition that summer. Called *The Progress of a Soul* and created between 1893 and 1902, these two-metre high textiles, in four panels, illustrated the epic journey of the human spirit through life [**39**]. A narrative sequence inspired by a tale by the aesthete Walter Pater (1839–1894), the embroideries were intended as an expression of personal experience. They drew on a wealth of ideas from literature, music and the visual arts. A century on they still dazzle in their imagination, colour and sheer technical bravura.

Phoebe Anna Traquair occupies a unique position within British art. On the one hand, she was Scotland's first significant professional woman artist of the modern age. On the other, she was a valued contributor to the British Arts and Crafts movement. Believing in the indivisibility of the arts, this petite woman worked in fields as various as embroidery, manuscript illumination, bookbinding, enamelwork, furniture decoration, easel painting and, not least, mural decoration. Committed equally to public art and studio crafts, her career spanned four decades from the 1880s. She painted the interiors of no fewer than six public buildings, one of which has walls some twenty metres in height. The stained glass artist Louis Davis, having seen her at work perched high on her scaffolding, referred to her as 'a woman the size of a fly'. For the poet (and fellow Dubliner) W.B. Yeats (1865–1939), she was 'a little singing bird'.

This is the story of a confident woman who wanted to make her mark in the art world. In the 1890s and 1900s her studio crafts were exhibited and reviewed, her painted buildings written up in the press and regarded as showplaces to be visited. But her work, so intellectually and emotionally inspired by poetry and music, fell completely out of fashion during the Great War. In the 1980s her craftwork quietly began to resurface in British exhibitions, including *The Last Romantics* (1989) at London's Barbican Art Gallery. These, together with the gradual opening of 'her'

buildings on 'doors open' days and, above all, a large exhibition of her work mounted at the Scottish National Portrait Gallery in 1993, put her back on the cultural map. In this, the public has worked collectively with historians, curators and conservators to reclaim her for the art world. As a direct result her buildings are now treasured by their communities and her craft is in demand amongst collectors.

Seen against the background of her own age, Traquair shines out as a true professional. Driven by a need for creative fulfilment, she networked, negotiated commissions and participated in exhibitions in Britain, Europe and America. Her work may be classified as artistic craft: she was never a modern 'designer' but rather always brought an artist's mind and eye to whichever medium she was currently engaged. However, to call her a 'decorative artist' might be to limit her aspirations. Like many other decorative artists she delighted in nature, seeking to 'match the beauty of red-tipped buds, sunlight through green leaves, the yellow gorse on the hill, the song of wild birds'. The Edinburgh-based Arts and Crafts architect Robert Lorimer (1864–1929), a friend and associate, emphasised her common-sense attitude to life, commenting that she was 'so *sane*, such a lover of simplicity, and the things that give real lasting pleasure are the simplest things of nature'. Yet, while often immersed in the minutiae of the natural world, Traquair saw these, like the writer John Ruskin (1819–1900), as part of one vast grand plan. Her ideas, underpinned by Christian faith, were intended above all to reflect the immensity of spiritual life and culture.

In her art Traquair wished to celebrate the potential of the human mind. The poetry and art of William Blake (1757–1827) and Dante Gabriel Rossetti (1828–1882) were valued for their exploration of the spirit. In addition, the epic romance was a literary form enjoyed for its rich and traditional narrative of journey and resolution. To realise her work Traquair responded to past arts, uniting ideas in order, perhaps paradoxically, to understand and engage fully with modernity.

Traquair's concerns were with both personal values and universality, and with the role of art within society. Whilst never a follower of fashion, her approach to art was, nonetheless, linked to the enlightened humanism of her age and specifically to Arts and Crafts ideals. The scale of her ideas and her synthesising romanticism were also in line with modern thinking across the creative arts. *The Progress of a Soul*, in its textures, finely-tuned

colours and rich imagery, was intended to assimilate nature, man and God to 'mirror the whole world', to use words applied by composer Gustav Mahler to his cosmic third symphony, a work composed in parallel.

With a focus and resolve as keen as those of many of her contemporaries, Traquair may be called a modernist. In particular, in seeking to imagine and illustrate an account of life's journey, she shared ideals with a range of modern artists, poets and composers. John Duncan's Celtic murals in Edinburgh's Ramsay Garden, even Edvard Munch's great *Frieze of Life*, and, in music a few years later, Frederick Delius's *A Mass of Life* and Ralph Vaughan Williams's setting of Walt Whitman's poem *Toward the Unknown Region* were among works which also explored the range of human experience. *The Progress of a Soul*, a narrative worked out across four movements or verses, was directly and intuitively inspired by both music and literature. A visual tone poem, it is a heartfelt, mature reflection on 'life's rich tapestry'.

This book, also in four parts, sets out to place these embroideries within the context of her life and work. Different chapters look at her early involvement in widening the role of art in society, her development of poetic ideas and creative synergy, and her desire to participate in the shared, professional world of art and craft. Threaded thematically through the book is her principal theme, identified by Yeats as 'the drama of the soul'. Using her own words and those of friends and contemporaries, this study sheds new light on the ambitions of late Victorian and Edwardian culture.

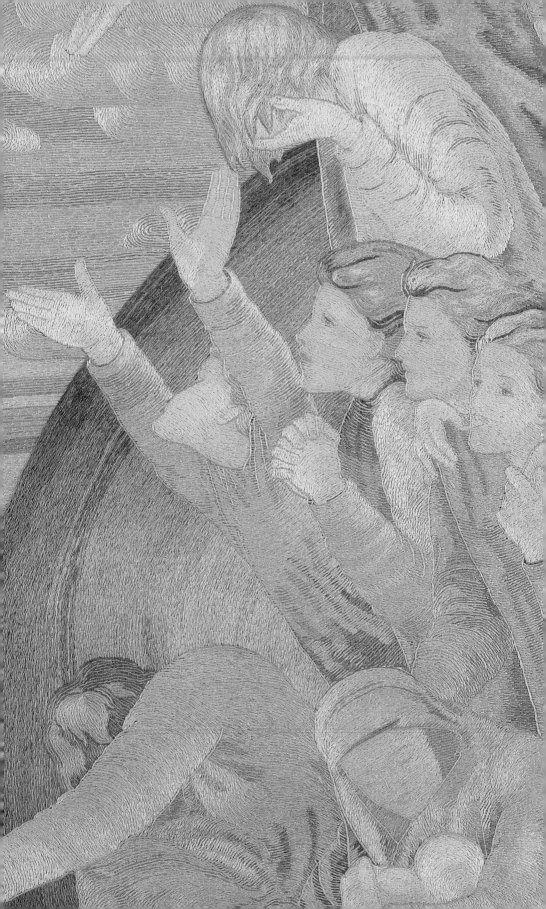

1 Art and Life

Phoebe Anna Traquair was an independent artist. While many women associated with the Arts and Crafts movement had the professional support of a father or husband, she was married not to a designer or architect but to a scientist. However, she enjoyed a close personal and artistic dialogue with a brother seven years her senior. William Moss was a Lancashire cotton manufacturer who collected art and owned paintings by the Pre-Raphaelite artist and poet Dante Gabriel Rossetti, a poet-artist whose work was to inspire Traquair deeply. Only in the 1900s would she work in any kind of proper professional partnership, and here it would be with her elder son, Ramsay, rather than a member of her own generation. As a young architect, he shared her ideals and designed frames for her display enamels.

Traquair's background was respectably middle class. She was born Phoebe Anna Moss, the third daughter and sixth child of Dublin physician Dr William Moss and Teresa Richardson Moss, in Kilternan, on 24 May 1852. There were seven children in all, three sons followed by four daughters. The eldest, Edward, would become a naval surgeon, but tragically was lost at sea in 1880. William Richardson Moss was the second son, and the third son, Richard, became a public analyst and secretary of the Royal Dublin Society. Of her three sisters, Phoebe Anna would remain closest to Amelia, her immediate elder, who never married.

All the family enjoyed a mix of formal education and visits to local collections, including the library of Trinity College with its marvels of medieval illumination. The *Book of Kells* was a particular favourite, and Phoebe Anna soon showed a penchant for art. Encouraged by her parents, she received a Department of Science and Art 'South Kensington' art training in the late 1860s with the Royal Dublin Society. This nationwide training, with its emphasis on copying and visual awareness, involved classes in figure drawing, and drawing from antique casts, ornament and modelling. Of these, figure drawing, with its principles of light and shade, drawing from nature and painting in watercolours and tempera, would most inform her work. She won a student award for copying from the antique. This immediately provided an

The Salvation of Mankind
Detail showing *Souls Waiting on Earth*, 1891–3

introduction to the Scottish palaeontologist Dr Ramsay Heatley Traquair (1840–1912), Professor of Zoology at the Royal College of Science in Dublin since 1867, who was seeking an illustrator for his research papers. Traquair, a son of the manse, was born in Rhynd, Perthshire. He was brought up in Edinburgh from whose university he had graduated with a gold medal for a thesis on asymmetry in flatfish. It was an immediate attraction of opposites – Ramsay the quiet academic and undemonstrative Scot to Phoebe Anna the impulsive redhead. The headstrong Annie, as she was known in the family, soon announced her intention to marry him. They did so in Dublin on 5 June 1873 [**1, 2**]. With an extraordinary eye for fine detail, she would quietly illustrate his papers throughout the next thirty years. With her husband's appointment as keeper of Natural History at the Museum of Science and Art (later the Royal Scottish Museum and today the Royal Museum) in Edinburgh they moved to Scotland in the spring of 1874, setting up home at 8 Dean Park Crescent in the west end of the city. Their three children would inherit their parents' shared love of the natural world and studious approach to the arts and sciences. They also had their differing temperaments: sons Ramsay, born in 1874, and Harry, born the following year, both took after their father, while Hilda, born in 1879, was more like her mother.

In the 1870s Phoebe Traquair's world was essentially grounded in the closeness of domestic life, supporting her husband and raising their family. She engaged in the socially acceptable arts of landscape watercolour painting and domestic embroidery. Yet already her expectations were not insignificant. She explored the collections of her husband's museum and enjoyed its

[1] Phoebe Anna Traquair 1873
[2] Ramsay Heatley Traquair 1873
These carte de visite photographs of the Traquairs were taken by the firm Gebrüder Siebe of the Hotel Stadt Dresden in Leipzig on 1 September 1873. They were given to a friend of Dr Traquair, the zoologist William Carmichael McIntosh.
University of St Andrews Library

[3] Table Cover *c*.1880

Wools, silks, and gold thread on textured crash 83.8 x 89 cm

The design features birds, monkeys, butterflies and insects against a trellis of flowering cacti in a profusion of nature. In this textile made for her own home, Traquair exoticised William Morris's celebrated 1864 wallpaper design *Trellis*. Her interest in the values of colour and texture are already apparent. Pink and lilac crewel wools and silks provide a foil for the use of gold thread.

Victoria and Albert Museum, London

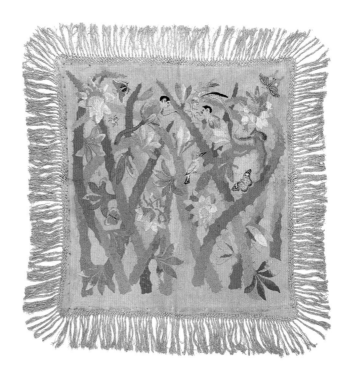

varied decorative art exhibitions. One of these was the 1878 display of *Art Needlework* which included not only the work of the new Royal School of Art Needlework in London, but a selection of international textiles. The school advocated work which would harmonise with contemporary styles of interior decoration. Traquair, while attracted to the Pre-Raphaelite-derived styles and stitchery, and original designs by William Morris, also took pleasure in the inventiveness and immediacy of European and Middle Eastern textiles, including Yannina embroideries from Greece. Her domestic embroideries of the late 1870s and early 1880s show her response to a variety of work, inventively assimilating natural forms and details with new and traditional stitches, while also developing her colour sense [3].

Despite such attractions, the Edinburgh in which the Traquairs had settled was a city dominated by the professions and limited both socially and artistically. Although there were a small number of private studios, the Royal Scottish Academy dominated the training of artists and the exhibiting of new work. Art shown to the public and approved by critics was almost entirely confined to portraiture, landscape, or narrative genres. Good 'finish' and high-minded moral subjects were what mattered. The impressionistic paintings of William McTaggart were found to be woefully 'wanting in texture and definition' by local critics.

As with many capital cities, 'high' art was a taste and status indicator. The bourgeoisie of Edinburgh's New Town bought, as it does today, from the annual Academy exhibitions. The New Town, however, was also home to much of the city's intelligentsia. Academics in particular, while supportive of Academy artists, also valued and contributed to cultural developments across Britain. And, as elsewhere in the country, several of these broke the insular mould of the visual arts by directly engaging with society through extramural classes. Some of these were held in Shandwick Place, the western continuation of Princes Street. Here were found exhibition halls, studios and businesses recruiting domestic staff. The street was also dominated by St George's Church, a Free Church charge which, under Dr Robert Candlish (1806–1873) and Dr Alexander Whyte (1836–1921), became a centre extraordinarily rich in theological debate, lectures and discussion groups during the second half of the nineteenth century.

Two academics particularly committed to extramural activities were also in touch with the lions of British literature. David Masson (1822–1907), Professor of Rhetoric and English Literature at the University of Edinburgh, maintained friendships with Thomas Carlyle (1795–1881), W.M. Thackeray (1811–1863) and Robert Browning (1812–1889), while Gerard Baldwin Brown (1849–1932), first Watson Gordon Professor of Fine Art from 1880, had been a colleague of Walter Pater at Oxford. They were welcome in a city in which antiquarianism was strong, with the Society of Antiquaries of Scotland Museum, superseded in 1889 by a fine new National Museum of Antiquities of Scotland. Other figures of Traquair's own generation were soon to occupy key positions within Edinburgh culture. John Miller Gray (1850–1894), the first curator of the future Scottish National Portrait Gallery whose building was shared with the Museum of Antiquities, also supported what the social thinker and botanist Patrick Geddes (1854–1932) called the 'higher harmonies' found in Symbolist art, poetry and literature.

Traquair had engaged with the city's literary culture by the mid-1880s and would find in it an intellectual strength for the next forty years. Gray was a self-educated art critic [4]. He was a close friend from 1884 when Traquair, whose art to date consisted of landscape watercolours and embroidered domestic linens, designed a bookplate for him in an aesthetic style. Gray was friends with writers and authors such as Dr John Brown,

[4] W.G. Burn Murdoch, *John Miller Gray* 1889

Pencil on paper 16 x 10.1 cm

A former bank clerk, Gray was a self-educated connoisseur and art critic. The artist W.D. McKay commented on his 'excessive admiration for the painters of the Aesthetic School'. The first curator of the Scottish National Portrait Gallery, Edinburgh, he lived nearby at 25 York Place where, according to the poets 'Michael Field', '*The Germ* was put in our hands, *The Defence of Guinevere* praised with zeal, Browning read aloud … and the art springing from Preraphaelitism discussed merrily.'

Scottish National Portrait Gallery, Edinburgh

ART AND LIFE

[5] *Improvisations from the Spirit* 1887

Ink and watercolour on vellum

Page size 19 x 15.2 cm

Garth Wilkinson's poem was translated into a series of remarkable ideas, some of which related to Traquair's recently completed children's hospital chapel. Having studied medieval manuscripts, her imagination produced images strong in colour and pattern.

Private collection

[6] *Ramsay and Harry* 1887

Pencil on paper 15.5 x 22.9 cm

In the autumn of 1887 Traquair enclosed this drawing of her two sons with a letter to Ruskin. A reminder that she continued to produce drawings and paintings in addition to her 'high art', it is affectionately inscribed: *Harry Traquair 1887. The long headed silent boy who takes in all and gives it out like a sledge hammer. Ramsay Traquair 1887. The round headed boy who takes in only what he likes, wakens now and then, and tells it.*

The Ruskin Foundation (Ruskin Library, University of Lancaster)

author of *Rab and his Friends*, the Scottish Pre-Raphaelite artist William Bell Scott, 'Michael Field' (the aunt and niece poets Katherine Bradley and Edith Cooper), Browning and Pater. Indeed, the last two refereed his application for curatorship of the Portrait Gallery. Gray's influence in introducing poetry to Traquair and, not least, encouraging the bold initiation of friendships, was important.

In the 1880s, as a home-based artist, Traquair thus quite naturally turned to literature as her intellectual source. Brought up in Dublin within easy reach of Trinity College library and the *Book of Kells* with its correspondence of colours, patterns and words, she set out to work not only as an illustrator, but as an illuminator. For Gray she created some of her strongest early images. Garth Wilkinson (1812–1899), the Swedenborgian poet and homeopathic physician best remembered today for his treatment of Rossetti's wife, Lizzie Siddal, was a favourite source. His *A Little Message for my Wife* and *Improvisations from the Spirit* were illuminated in 1884 and 1887 by Traquair for Gray [5]. Wilkinson was influenced by William Blake whose *Songs of Innocence and Experience* he had edited in 1857. Traquair's appreciation of Blake as poet and artist was both first-hand and through Wilkinson's interpretation, whom she may have possibly met in person through Gray: her *Improvisations from the Spirit* title page has a watercolour portrait of him.

As Gray had introduced himself to poets, so Traquair boldly wrote to the writer and collector John Ruskin in 1887 for advice on medieval illumination. Their correspondence over several months consisted of the loan of manuscripts, particularly those of the thirteenth century, from Ruskin's library for both study

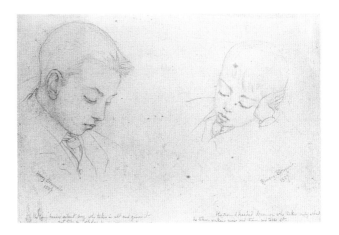

[7] *The Dream* 1886–7

Ink and watercolour on vellum

Page size 12.1 x 11.5 cm

Traquair's imaginative illumination of her own poem used primary colours. When the manuscript was bound in cover she tooled the title *Melrose* on the spine. This was the title by which it was henceforth known.

National Art Library, Victoria and Albert Museum, London

[8] *The Children's Guide* 1890

Page size 25 x 13.6 cm

This paper was the juvenile companion to *The Social Pioneer* also published by David Balsillie in Edinburgh. It was modelled on such earlier magazines as Julia Horatia Ewing's *Aunt Judy's Magazine*. Contributors included John Miller Gray on the artists Chardin and Velázquez. In 1889 and 1890 Traquair provided not only the cover design, but also illustrations which suggest knowledge of work by William McTaggart, Walter Crane and Selwyn Image.

National Library of Scotland, Edinburgh

and copying. In return, Traquair sent not only originals and copies, but some new work such as her own narrative text, *The Dream* (1886–7), which he described as 'beautiful leaves which I could not resolve to part with'. They discussed the poetry of Walt Whitman and Traquair sent him a drawing of her sons [6].

Even at this stage Traquair's illuminated manuscripts were already packed with imagination. From about 1884 until the early 1890s she illuminated individual Psalms of David, working out imagery that would later find a place in different media. *The Dream* was different [7]. Her style here was free of medieval influence and inspired by Blake, a copy of whose *Songs of Innocence and Experience* she sent to her sister Amelia. As with her 1887 painting, *The Awakening*, an interpretation of the third verse of *Songs of Experience*, *The Dream* was an early attempt to give literary and visual form to her thoughts. It is a visionary tale set in Dryburgh Abbey and written in the style of Wilkinson.

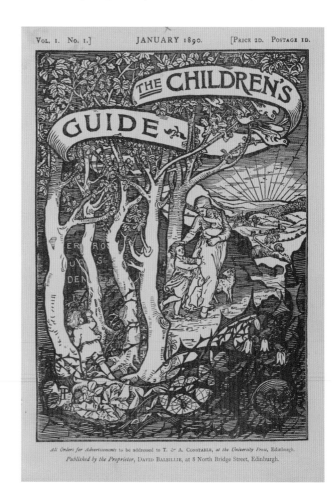

The primary colours she introduced were brave and bold, strengthening and resolving the text. In 1889 the words of David Balsillie, an Edinburgh cleric, publisher and critic, would echo her approach: 'form and colour elicit powerful and exquisite emotions to which they alone have the key'.

These words come from a book entitled *Studies of Great Cities: Paris*. Balsillie was no modernist. He considered that the function of art was 'not to amuse but to elevate mankind'. Working with and for society, he published religious magazines such as *The Children's Guide* and *The Social Pioneer*. Traquair provided many figural illustrations to these in the late 1880s [8]. Her cover design for *The Children's Guide* (1889) initiated imagery in which the symbolic world of nature combined with figural content – an approach which would find a place in *The Progress of a Soul* only a few years later. By uniting the worlds of nature and Christianity, Traquair was also issuing a riposte to Darwinism. This was not particularly Scottish, but British work. Indeed, in its sunrise, bannered lettering and flying birds, it related more readily to recent English Arts and Crafts graphic or textile design. This is not surprising as the London-based designer Walter Crane (1845–1915), and Selwyn Image (1849–1930) were both designing for Scottish publishers. Image was involved in the magazine, *The Scottish Art Review* (1888–9), produced to draw together art, literature and music, and edited by Glasgow economist James Mavor. It was one of the few Scottish periodicals to encourage articles on English culture and French art as well as promoting the naturalistic work of the 'Glasgow Boys'. In addition, Crane and A.H. Mackmurdo, designer and founder of the Century Guild (a commercial collective of designers and artists), lectured in Glasgow and Edinburgh.

Traquair's experience in designing covers and illustrations for commercial publications such as *Women's Voices*, a 1887 London anthology of women's poetry edited by Elizabeth Sharp, engaged her directly with society [9]. This, however, was not her earliest or indeed most direct experience of working for her public. In early 1885 a circle of enlightened academics, artists, clerics and philanthropists formed the Edinburgh Social Union to take art from private studios into the public domain. Their purpose – governed initially by an environmental society proposed in 1884 by Patrick Geddes – was to provide art, music and a natural environment that would transform the daily lives of the working

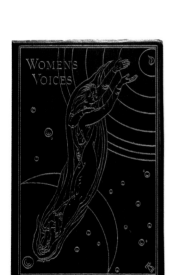

[9] *Women's Voices* 1887

Cover 19.1 x 13.6 cm

An early anthology of verse by women poets, *Women's Voices* was published in London by Walter Scott. Traquair provided both the frontispiece and this cover design for the commercial edition. For her cover image she reused a suitably feminine image from her *Improvisations from the Spirit*. In its debt to Flaxman, the cover underlines her eclectic range of sources by this date. The editor Elizabeth Sharp selected a wide range of poets from Lady Nairne to Christina Rossetti and Alice Meynell.

Private collection

[10] *Motherhood*, Chapel of the Royal Hospital for Sick Children, Edinburgh 1885–6 (detail)

The focus of her first mural scheme, the subject of motherhood was Traquair's first major attempt at a specifically religious image. She was already synthesising cultures by this stage, from Orthodox icons to the Virgin and Child in European medieval manuscripts. The room decoration was meant to comfort local mothers.

NHS Lothian, University Hospitals Division

[11] *Angel Powers*, Chapel of the Royal Hospital for Sick Children 1885–6 (detail)

The panel of three angels was painted on the opposite wall to *Motherhood* [10] in both the original and the 1890s children's hospital chapels. Removed from the first chapel prior to its demolition in 1894 it was repositioned on the south wall of the present building at Rillbank. Each angel holds a transparent globe in which Traquair painted scenes representing the development or journey of the spirit – a wreath of grass, a holy knight fighting a dragon, and a cross with spirits 'shouting for joy'. She also included inscriptions such as 'go forth be fruitful and multiply' and 'Death is the author of Life'.

NHS Lothian, University Hospitals Division

classes across the city. A programme of mural decorations in public buildings was matched by craft classes where the working classes were taught to create their own beautiful surroundings. In Edinburgh the impetus for such work was the squalor of the Old Town, which recent legislation had failed to improve. Traquair was one of the first artists to provide mural art and, as appropriate for a young mother, she painted the walls of a new chapel for the Royal Hospital for Sick Children.

The early activities of the Social Union demonstrated the small scale and close workings of Edinburgh society. Time and time again connections may be made between its artistic, social and, particularly in this period, philanthropic circles. John Ritchie Findlay (1824–1898), proprietor of *The Scotsman* newspaper, served on its decorative committee; he was also a director of the hospital. Moreover, he was the benefactor of Gray's Scottish National Portrait Gallery. Traquair's commission, therefore, was far from accidental. It was also in response to a direct plea from the hospital ladies' committee who wished nothing 'extravagant or highly decorated but a suitable place where the bodies can be left reverently and lovingly for the parents before the burials'.

The ladies must have been startled by what was realised. A disused hospital coalhouse measuring only four by three metres was transformed into a chapel. Painted by Traquair during 1885 and 1886, it was regarded by the press in 1887 as 'the most important and memorable portion of the art of the Social Union'. Gerard Baldwin Brown, in 1889, would write in *The Scottish Art Review* that it was 'a piece of illumination enlarged' with 'the same curious elaboration of symbolic detail, the same fresh and cheerful appearance, the same refinement in drawing and execution'. Traquair, by now used to responding to literary sources in her art, knew that she wanted to provide a Christian response to bereavement. She took a New Testament text (Matthew 16:25), 'For he that will save his life shall lose it and he shall lose his life for My sake, the same shall save it' and wrote it in large Gothic gold lettering against a strong red background. As in the 1890s she would write of the twin inspirations of literature and architecture ('if I meet with a book which stirs me, I am seized with the desire to help out the emotion with gold, blue or crimson; or, is it a wall, to make it sing'), so here text and building were seamed together in an act of comfort.

The focus of the entire room was the panel immediately above

this text, painted, like the entire room, in the same primary colours and gold of her illuminated manuscripts. Depicting motherhood, it showed the Virgin and Child with attendant angels [10]. It was an image which, as Baldwin Brown remarked, was at once based on ideas from Western manuscripts and Eastern Orthodox imagery. Traquair intended it to be 'Eve redeemed through Christ, or Nature redeemed through the incarnation of the Divine Spirit'. Even at this early stage in her career she was working eclectically and feminising her imagery where appropriate.

The walls of this tiny, top-lit room were also coated with images of white-robed angels, arms outstretched, and of divine and mortal motherhood, accompanied by symbols of the passage of the soul through and beyond life. Some images showed an awareness of Italian art, others were closer to Pre-Raphaelite work, especially that of Rossetti. The wall opposite the principal *Motherhood* panel illustrated three 'female' angels or divine powers holding globes illustrating scenes from the journey of the spirit [11]. Other scenes depicted the Crucifixion as the door to eternal life. The room's decoration, intended to comfort parents, was essentially one of departure and arrival of the spirit, the transfer from this life to the next. But, by also presenting the journey through this life, Traquair entered into a theme which would be the focus of her entire career.

According to W.B. Yeats, writing in 1906, Traquair was 'forbidden to paint' (by her husband Ramsay) and this decoration was worked 'in stolen hours'. At this early stage especially she must have been torn between duties of house and home and her own career. She was not yet ranked as a professional artist. Although she had been granted a commission, only the reimbursement of paint expenses was paid. Her art was still mostly worked at home, behind closed doors. Yet illuminated manuscripts and embroidery could provide fields for rich experimental work and also develop themes first worked into her chapel.

In the year she completed her chapel she embarked on the first of three suites of embroidered panels. Collectively entitled *The Salvation of Mankind* (1886–93), they domesticated ideas initiated in her chapel [12]. The triptych was a format with impeccable medieval and Renaissance credentials that could endow art with a sense of universal truth. Traquair matched the triptych to her religious subjects, finding in it a ready symbol of the Trinity. For her hospital chapel (in addition to her triumvirate

ART AND LIFE

of angels) she had already framed three preparatory studies together, decorating the frame three times with three interlocking circles. As a leitmotif this would also be applied to the reverse of her leather bookbindings in the late 1890s.

The three panels which together compose *The Salvation of Mankind* constructed a more precise narrative, that of the judgement of the soul in death. Each embroidery took approximately eighteen to twenty months and was monogrammed *PAT* and dated at the foot on completion. Traquair inked her outline design on her linen and stitched her silks on a large, wide frame. She used a variety of traditional stitches – couching, stem stitch and long and short stitch. Each was detailed independently although the general narrative was carried across all three. The central panel, the first to be sewn, was given the title of *The Angel of Death and Purification*. Following a small oil sketch of 1885, *Spiritus Caritas*, an angel with a golden halo bearing the motto *Caritas* (Love) weighs the souls of the deceased using a flaming skull from which rises a phoenix, the traditional symbol of rebirth. The composite nature of Traquair's design may be seen in the costume which includes both a scene of the sacrifice of Abraham and details from nature. Her angels are fashionably dressed in Renaissance-style gowns. The physiognomy is close to a Rossettian style of beauty, but this red-winged creature may rather have been inspired by a well-known Edward Burne-Jones (1833–1898) embroidery design of 1884 for Frances Graham. That also was an angel of love, *L'Amor che muove il sole e l'altre stelle* from the *Paradiso* of Dante's *Commedia*.

The iconographic sequence of these embroideries narrated Christian redemption, again an echo of the chapel work. The two wing panels, completed in 1891 and 1893, were worked in reverse narrative order. The earlier was given the title *The Souls of the Blest*. There seems to have been a gap of some two years before Traquair put this second design on her frame. A line of angels receive with outstretched arms the souls who have passed through judgement. The simplicity of treatment of the background – the cumulus clouds (also used in her chapel) of heaven and the waters of the deep – is startling, almost Japanese, by comparison with the central panel. The third panel, *Souls Waiting on Earth*, depicts agitated figures awaiting their judgement. While including a further quiet image of maternity, iconographically this wing in its dramatic figural gestures has most in common with north Italian altarpieces, adapting images from a

[12] *The Salvation of Mankind* 1885–93
Silks and gold thread on linen
each 185.4 x 67.3 cm, left to right:

The Souls of the Blest 1889–91
The Angel of Death and Purification
1885–7
Souls Waiting on Earth 1891–3

While collectively presenting a dramatic
narrative, each of the three panels has its
own identity which draws on sources
varying from Victorian to Italian religious
art. Their colours now faded, all were
originally worked in the brilliant reds,
blues and golds of the hospital chapel
decoration and her early illuminations.
The central panel especially used
traditional stitches, such as couching,
creatively and to speed the making. The
flicking lines of the angel's hair – red, like
that of the Moss family – and costume
details provide an animated design.

City Art Centre: City of Edinburgh Museums
and Galleries

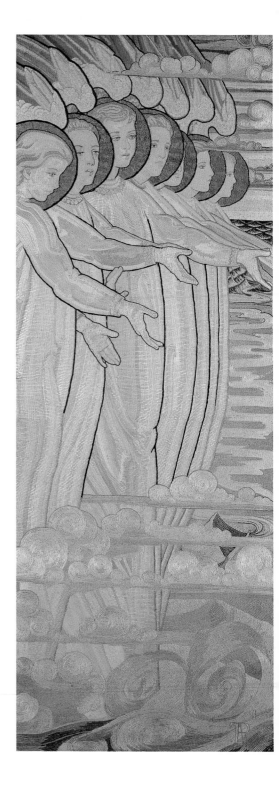

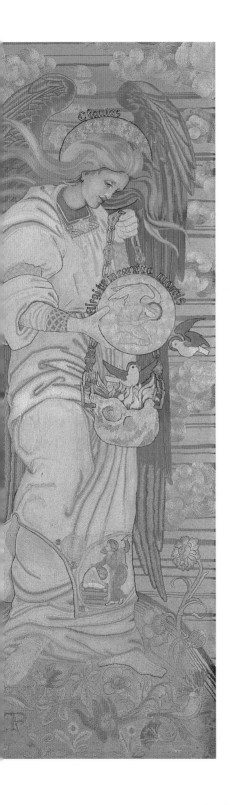

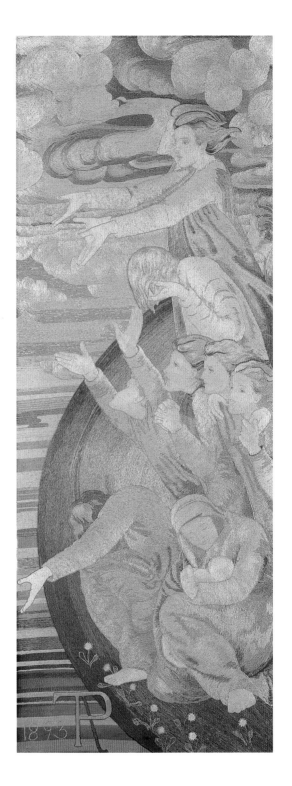

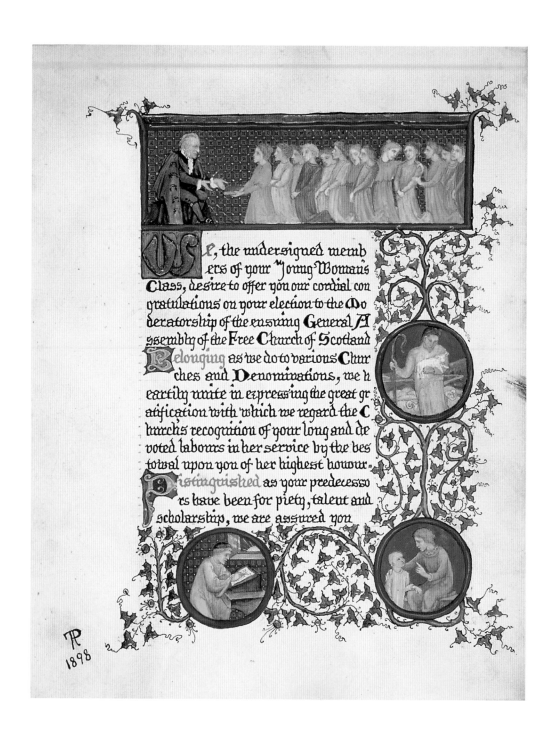

We, the undersigned memb ers of your Young Woman's Class, desire to offer you our cordial con gratulations on your election to the Mo deratorship of the ensuing General A ssembly of the Free Church of Scotland Belonging as we do to various Chur ches and Denominations, we h eartily unite in expressing the great gr atification with which we regard the C hurch's recognition of your long and de voted labours in her service by the bes towal upon you of her highest honour. Distinguished as your predecesso rs have been for piety, talent and scholarship, we are assured you

TP
1898

Crucifixion or an Assumption. The three embroidered panels thus present a wide range of influences and ideas.

Like most artists, Traquair discussed her ideas with her immediate circle, a number of whom, like Gray, helped focus her images. Another friend who from the 1880s affected her thinking was the Free Church theologian Dr Alexander Whyte. In August 1885, as Traquair began her chapel, his son George died at the age of only six months and sympathy may have triggered their friendship. Like many Free Churchmen, Whyte was a liberal thinker and intellectual with a strong popular following. At 'Free St George's' he offered winter discussion groups open to all members of his congregation and any others who expressed interest. They were called Young Men's and Young Women's Classes, although, as his nephew and biographer George Barbour wrote, the term 'young' was loosely applied [13]. These lectures and debates were 'literal and ethical' or 'doctrinal and experimental', with Whyte encouraging his congregation to link their wide reading to experience.

Whyte particularly encouraged his classes to read Dante and to consider the journey of the soul in practical and symbolic terms, as part of their daily lives. In short, each person was invited to engage on a journey of spiritual development. A member of his Young Men's Class was the future author and playwright, J.M. Barrie (1860–1937). Their families had known one another in their home village of Kirriemuir in Forfarshire (Angus) and in 1878 the young Barrie, newly arrived at university in Edinburgh, had been taken under the wing of the Whytes. Barrie's best-known work, *Peter Pan* (1904), partly influenced by Whyte, was to be written for an adult audience as much as children (as Traquair's chapel, indeed, had been painted). In Barrie's secularised story of faith, Peter cheats death by never growing up and he flies like an angel. He urges the audience to save a life (the fairy Tinker Bell) by stating their belief (in fairies). Elsewhere Barrie edged closer to theological ideas: his Lost Boys may be the souls of dead children, marooned in the Never Land of limbo.

When Traquair painted her chapel some eight percent of British children died before their first birthday. Barrie, who had lost a brother in childhood, was always aware, like her, that young life was precarious and precious. He chose to assign the rights of *Peter Pan* to the Great Ormond Street Children's Hospital, London's equivalent of Edinburgh's Hospital for Sick

[13] Address illuminated for Dr Alexander Whyte 1898

The headpiece shows Whyte receiving the bound address from the Young Women's Class of his charge, Free St George's, on the occasion of his election to Moderatorship of the General Assembly of the Free Church of Scotland. Roundels at the side of the page illustrate Christ the good shepherd and Christ with a child. Traquair included a self-portrait as illuminator lower left.

St George's West Church, Edinburgh

Children. Barrie and Traquair shared not only the friendship of Whyte and his wife Jane, but also their interest in the spiritual journey as the base of true experience. Much later Jane Whyte would also take a deep personal interest in the universality of the Bahá'í faith.

It was, however, Dante's *Commedia*, the Italian poet's great narrative of life, love and loss, joy and pain, which, thanks largely to Whyte, was to impact most strongly on Traquair. In the spring of 1889 she visited Italy in a party led by the Whytes. The group also included Jane Whyte's brother Robert Barbour and his wife Charlotte, and another theologian, John Sutherland Black, who had served on the Social Union decorative committee. They enjoyed Traquair's company, her forthright manner, humour and quick wit and her wide cultural engagement. The decision to leave behind her growing family – a daughter of nearly ten and two sons in their teens – showed her dedication to art, but perhaps it also resolved the seeming intensity of her

[14] *I, even I, am Beatrice* 1889

The frontispiece to *Dante Illustrations and Notes* (1890) is typical of the late 1880s in its figural group, clouds and *poudré* carnations, symbols of passion. The last detail, deriving from both Botticelli's art and Rossetti's book design, was adapted, gold against crimson, for the endpapers. Traquair produced twenty illustrations plus the cover, frontispiece and title page designs.

National Library of Scotland, Edinburgh

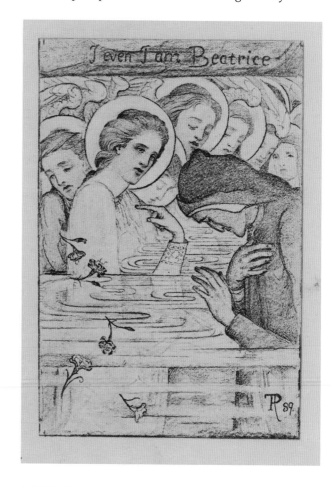

ART AND LIFE

friendship with John Miller Gray. They had planned, apparently, to go to Italy together in the late 1880s. Their affair, such as it was, is undocumented as Traquair's family subsequently destroyed Gray's letters. This first visit to Italy was a revelation. George Barbour would write that 'to one of her sensitive insight, the work of the early Tuscan painters and sculptors, which she now saw for the first time, came as a true revelation; and her companions found their appreciation heightened by her enthusiasm'. She found in the work of Fra Angelico (c.1395–1455) an 'entirely spiritual mind, wholly versed in the heavenly world and incapable of conceiving any wickedness or vileness whatsoever'. The romance of Sandro Botticelli's art also made an impact and would especially inform her mural decorations over the coming decade.

The party discussed Dante at length in Florence and back home in Edinburgh. Traquair agreed to illustrate a small book with scenes from his poems, also supplying a frontispiece of Dante and Beatrice [**14**] plus a design to be etched for the cover. Black would provide notes on the chronology of the *Commedia*. The rest would be a series of essays by Whyte. Her text illustrations were not dissimilar to Botticelli's own published illustrations to Dante, with small figures located within a deliberately diagrammatic format. Whyte approached Walter B. Blaikie (1847–1928) of T. & A. Constable to publish the book which appeared in 1890, finely printed and with 'Blaikie red' endpapers and cover. As published, the book represented a studied, fresh response to both Dante and Whyte. Its success led to illustrations for other books over the next decade – John Bunyan's *Holy War* and *The Pilgrim's Progress*, and also cover designs for further books written by Whyte and printed by Blaikie, a friend for whom as late as 1923–4 she would design garden railings in their village of Colinton.

Over a short period of some five years Traquair had secured a place for herself within Edinburgh society as a mural painter and illustrator. She had forged friendships which nourished her inquisitive intellect and provided companionship outside her immediate family. Engaging with the needs of society for her first commission, she considered the modern notion of 'art for art's sake' in the 1880s as shallow, and lacking in moral and spiritual values. But as her artistic knowledge and experience deepened, so increasingly she valued the arts for their own rich values and potential.

2

Music and Poetry

In the autumn of 1888 Traquair started work on the second of her Edinburgh buildings, a mural cycle for the Song School of St Mary's Episcopal Cathedral. This free-standing twenty metre-long building designed by John Oldrid Scott had been recently completed to serve (as it still does today) as a room for choir practice, but it was also then used as a community hall. The cathedral's sub-dean, Dr Casenove, was actively involved in the art activities of the Edinburgh Social Union and instrumental in gaining her the commission, a work which, working part-time, took her four years to complete.

The 1889 visit to Italy with the Whytes had come at the right time. The east wall was already half-complete with a self-contained central section of the decoration focused on a triptych of *The Three Marys at the Empty Tomb* (appropriate to this cathedral) flanked by *The Healing of the Dumb Man* and *The Gift of the Holy Spirit at Pentecost*, two New Testament subjects dealing with vocal powers if not song itself. Traquair set these scenes in the Scottish Borders – a favourite motif, the Leaderfoot viaduct, standing for the here and now. Country and cottage garden flowers fill the foreground. Her painted 'frame' for these scenes refers to the cathedral architecture, but also included lunettes detailing scenes from the Old Testament and the life of Christ in a similar style to portrait medallions next to her *Angel Powers* in the hospital chapel.

Painted in broadly naturalistic terms, these panels had begun to bond the physical and spiritual worlds on a scale hitherto unrealised in Traquair's work. More remarkable, however, were the two side sections of this wall, which in a new mix of realism and imaginary ideas, connected these scenes with a modern humanist age. Projecting her decoration firmly into the present, Traquair provided portraits of the cathedral clergy and choir, singing 'a sevenfold chorus of hallelujahs and harping symphonies' in front of a Scottish Borders landscape. These figures, who include the Bishop of Edinburgh and fellow Dubliner, Dr John Dowden, are ranked according to age rather than ecclesiastical seniority [15]. All are part of, and relate to, the surrounding

South wall of the Song School
Detail showing *'O Ye Powers of the Lord'*
1889

[15] East wall of the Song School of
St Mary's Cathedral: Bishop John
Dowden, clergy and cathedral choir
1889 (detail)

The Song School is a glorious mix of
imagination, realism and beautiful
details. Either side of her 'altarpiece' on
the east wall, Traquair painted two
separate but complementary east wall
sections in which she depicted the
cathedral clergy and choir.

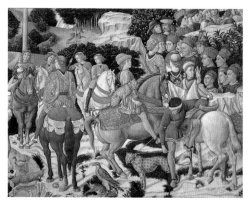

natural world. As the young architect Robert Lorimer (1864–
1929), a member of the Social Union decorative committee and
by now a friend, would comment in 1892, 'the idea is morning,
and birds circle joyously about'.

In its sense of modernity, these sections relate directly to
British art. The idea of choristers singing on a spring morning
was also the subject of the painting *May Morning on Magdalen
Tower* (1888–90, Lady Lever Art Gallery, Port Sunlight) by Pre-

Raphaelite artist, William Holman Hunt (1827–1910). Holman Hunt, also interested in the modern crafts, had the painting framed in repoussé copper by C.R. Ashbee's Guild of Handicraft. Traquair was acquainted with Holman Hunt and included his portrait in the Song School's south wall decoration in 1889. By 1894 she knew him sufficiently well to stay with him on her return from a second Italian visit.

However, there is, as ever, much more to Traquair's painting than simply a traditional British delight in nature. In a variety of respects her portraiture related directly to her Florentine experience. The impact of Fra Angelico's art, and especially his use of colour, was immediate and noted in correspondence with her nephew William (Willie) Ernest Moss (1876–1953). Her brother William had been recently widowed: although he remarried, Traquair took it upon herself to be 'intellectually responsible' for his son and started a remarkable, supportive correspondence which meant much to both. She wrote to him that Fra Angelico's art 'really belongs to the lyric but it is so purely spiritual I can't compare him, unless it be to spring flowers, or boys' voices, or birds'. The formal, stacked figural grouping was a response to both modern group photography – the cathedral commissioned such records of the choir and clergy [16] – and Italian Renaissance decoration. In, for example, Florence's Riccardi Chapel, painted by Benozzo Gozzoli from 1459, portraits of the Medici court form the procession of the Magi [17]. In Edinburgh, Traquair gave her two cathedral groups donor roles either side of the central triptych.

Although Traquair had already included landscape behind earlier figures, panoramic vistas of Scotland (north section) and Ireland (south section), her adopted and home countries, were more typical of Italian than British work. Plain, rounded arcading painted behind the figures was a nod to Florentine architecture. Above, soaring bands of singing angels linking heaven and earth also reflected her experience of Renaissance altarpieces. And, as was often the case in Florentine art, each individual angel figure here was a portrait, perhaps of a sister of a chorister or a daughter, wife or friend of a member of the congregation.

Yet her seemingly Italianate assimilation of the seen and unseen, the worlds of nature and the imagination, also reflected current thinking within the decorative aspect of the Arts and Crafts movement in Britain. Every single experience fed the mind

[16] **The choir of St Mary's Cathedral 1889**

The group includes Dr Thomas Collinson, cathedral organist and choir master, and John Keith, schoolmaster (back row, first and third from left).

Private collection

[17] **Benozzo di Lese di Sandro Gozzoli, The Journey of the Magi c.1460 (detail)**

Having seen the four painted walls of this chapel, Traquair would translate some of its key decorative ideas into a modern, local idiom in her Song School decoration. Gozzoli's grouped portraits of members of the Medici court (and angels) inspired Traquair's east wall decoration. His processions of the Medici, so rich in colour, variety of detail and panoramic composition influenced her long south wall.

Palazzo Medici-Riccardi, Florence, Italy

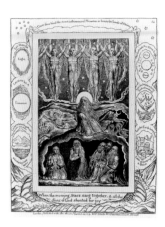

[18] William Blake, 'When the morning Stars sang together, & all the Sons of God shouted for joy', Plate 14 from *Illustrations of The Book of Job* 1825

Traquair used Blake's repeating angel image in all her mural decorations of the 1890s. In his *Hobby Horse* text, Selwyn Image was responding directly to Blake and to Ruskin's comment that Blake's *Job* was 'of the highest rank in certain characters of imagination and expression'.

Scottish National Gallery, Edinburgh

of the artist or craftsman, providing a rich sourcebook on which to draw. Selwyn Image, in a 1886 issue of *The Hobby Horse* (a London magazine issued by the Century Guild) neatly documented the inclusive ideals of art so bound up with life and its open range of aspirations and experiences. His words anticipated Traquair's work at the Song School:

> … the region of Art is in the Imagination … for the Imagination and for Art then there is neither fixed place nor fixed time. With the Sons of God shouting for joy at the Creation; with Adam in Paradise, or the shirt-maker in a Soho garret; with Christ desolate on the cross … with dreams of the virtues and habitations of Heaven, or with the record of some storm-swept Eastern Counties heath; with all these, and with all the varieties and contradictions of human experience or of human thought, Art interests itself. Yesterday, and To-day, and Forever – they are alike hers …

In 1891 Traquair would write of an infinity of ideas, and of the poet who takes 'joy in objects quite apart from the artist, as in some of Shelley's songs, the joy in external nature, or imaginary spirits'. She turned directly to Blake as her source, painting the west wall either side of the Henry Willis organ with two pairs of red-winged seraphs based on his celebrated *Book of Job* image, 'When the morning Stars sang together, & all the Sons of God shouted for joy' [18]. This was a celebration of the union of the human and divine. In the upper section Traquair represented souls who have reached heaven.

Traquair was now deliberately working microcosm with macrocosm in her representation of the wholeness of life. Inspired partly by Blake, partly by Dante, and partly, increasingly through the 1890s, by Dante Gabriel Rossetti, this would define the decoration's importance within the history of modern art. In 1892 Walter Pater, a writer of increasing significance to Traquair, would refer to Dante as having 'a minute sense of the external world and its beauties, a minute sense of the phenomena of the mind, of what is beautiful and of interest there, a demand for wide and cheering outlooks on religion, for a largeness of spirit in its application to life'. Such writings, and Traquair's visit to Florence in 1889, would combine with her own reading and illustration of Dante to unlock new possibilities in art. She had found a range of lyrical values to interpret the liturgical text agreed with the cathedral.

The canticle *Benedicite Omnia Opera* ('O Ye Works of the

MUSIC AND POETRY

Lord, Praise Ye the Lord') is a text which celebrates the Creation. It was popular with Arts and Crafts decorative artists such as Heywood Sumner for its range of images. As well as illustrating a mass of flora and fauna through this essentially figurative decoration, Traquair worked Creation imagery into much of the deep lower frieze. Now inspired by Dante and the sequential imagery and the marvellous colours of ecclesiastical narratives of Renaissance art, she produced one of the important mural cycles in Britain. This room would earn her several London reviews and, almost inadvertently, also provide her entry into the world of international exhibitions.

Between mid-1889 and 1891 she painted the two long south and north walls, the latter punctuated by windows above eye level. The south wall, however, provided her with a long sweep of plaster punctuated only by beamed ceiling supports. She illustrated the *Benedicite* both literally and symbolically, merging the lyricism of Quattrocento Italian art with British realism in her union of the arts. Bringing together music and literature through art was a huge ambition, but it was one into which she poured energy and imagination. All the figures were deliberately painted life-size to engage with the spectator, and as in Botticelli's *Primavera* (and indeed Morris company tapestries) they walk over a flower filled meadow. Halfway along this south wall Botticelli's figure of Flora was translated into one of Summer, turning away and bearing an armful of June roses.

Beside and above the entrance door Traquair introduced 'O Ye Angels of the Lord'. The panel above the door itself illustrates the awakening of the spirit as an angel sounds the last trump. In the first full-size south wall section, singing angels were painted in oils diluted with turpentine, thinned even more than usual to provide an exquisite translucency. They were lit by a transverse rainbow, symbol of a united earth and heaven. The first medallion in the border below illustrated 'the birth of the spirit'. Traquair's theme of a spiritual journey thus came into play. These companion scenes began a wall in which the words of the canticle were expressed in poetic colours and form. The realism introduced in 1888 was developed in portraits of important poets, writers and artists. Alfred, Lord Tennyson (1850–1892), and Robert Browning, Holman Hunt, Rossetti, Thomas Carlyle, Joseph Noel Paton (a figure sometimes mistaken for William Morris) and George Frederic Watts (1817–1904) were included to represent 'O Ye Powers of the Lord' [19]. Mingling with these

figures and the cathedral choir were angels, said in her guide published on completion of the room in 1892 to be the unseen, divine element in which men 'live and move and have their being'. A lunette in the deep border was created for all artists: 'inspiration comes in sorrow'.

Portraits of both the living and the dead were included – Browning had died in 1889 and Carlyle eight years earlier. Their words, however, lived on, providing meaning and beauty for the reader. Traquair's mural painting cut across time, the real and the imagined, as had that of the artists whose work she had so recently enjoyed in Florence – Fra Angelico, Sandro Botticelli and especially Benozzo Gozzoli [17] whose decorations were a revelation in their detail, composition, and arrangement of colour and tone.

The third and fourth walls to be painted were less focused on complex scenes. Single or group portraits of poets, including Dante and Blake, churchmen from Cardinal Newman to the Belgian priest, Father Damien, and explorers David Livingstone and H.M. Stanley were represented for the verses 'Holy and Humble Men' and 'Servants and Priests of the Lord'. Traquair wished to equalise society in her decoration. She had included a working family of four in the last (west) bay of the south wall, and choirboy portraits alongside those of Rossetti and Watts. In the centre of the north wall, the 'O Ye Children of Men' were represented by James Clark, the George Street decorator and heraldic painter who had prepared her plaster walls with as many as five coats of thick, white oil paint, and the cathedral's masons [20]. They pause on the cobbled city streets, the Half Moon Battery of Edinburgh Castle beyond, and precede scenes of the 'Fowls of the Air', 'Whales' and 'Seas and Floods', the last bringing the entire decoration to a swirling, triumphant climax.

Every single part of the walls was painted. Window recesses or embrasures were covered with scenes of St Cecilia, Tobias and the Angel, comforting angels, putti or floral decorations, or, in the case of the east window, the arms of the Bishops of Edinburgh. A sketch self-portrait in grisaille with start and finish dates '88' and '92' was placed beside the north door. Her technique was now extremely varied. The east wall was largely painted in the detailed, disciplined style adopted in her hospital chapel. Matt gold leaf was applied to create haloes. Paint was thickly applied in places, particularly for flower detailing. The heads of the choir and clergy were outlined in black, using a

MUSIC AND POETRY

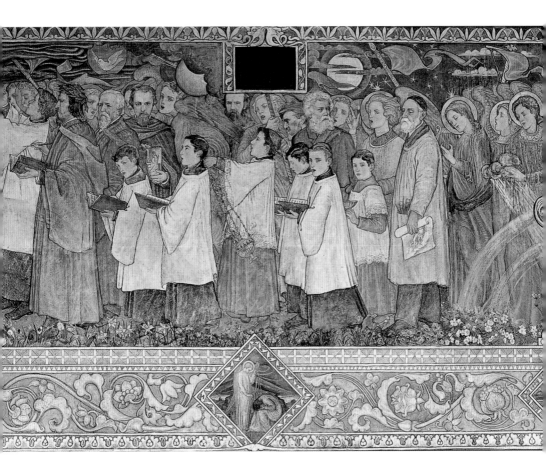

[19] **South wall of the Song School**
'O Ye Powers of the Lord' 1889 (detail)

In 'O Ye Powers of the Lord' on the south wall
Traquair included modern artists, such as
Rossetti, Holman Hunt and G.F. Watts, and
poets Tennyson and Browning, here wearing
their red Oxford doctorate robes, but no
scientist nor engineer, nor indeed any women,
are represented. Other parts of this
uninterrupted wall were painted with life-size
figures inspired by Morris company modern
tapestries or Botticelli's *Primavera*.

[20] **North wall of the Song School**
'O Ye Children of Men' 1890–1 (detail)

Traquair illustrated the equality of all art and
all levels of society. For a section illustrating
'O Ye Children of Men' on the north wall, she
painted James Clark, a heraldic painter and
decorator, and the cathedral masons.

sgraffito (scratch) technique. The south wall introduced new ideas. Working fluently in oils diluted with a paste mix of turpentine and wax, she was able to paint more expressively than ever before, wiping away paint to provide highlights. This is most clearly seen in her painting of the angel powers where the colours shimmer. The effect, as *The Journal of Decorative Art* commented in May 1892, was of an 'angelic choir, gracious in form, in flowing white vestments, on which prismatic hues play'.

Reviews began to appear. Gerard Baldwin Brown wrote in *The Scottish Art Review* even before Traquair visited Italy that her work had gained 'increased simplicity and strength'. Robert Lorimer loyally wrote on completion of the room that 'the idea of Praise forms the theme for the decoration and this has been worked out with a wealth of imagination, and instinctive feeling for design and colour, and an amount of affectionate industry that has probably not been witnessed in the decoration of any other building of today.'

In London the scheme was picked up by leading critics. *The Journal of Decorative Art* was one to review immediately, earning her recognition beyond Scotland. Many focused on the overall colour scheme. This journal reported that 'the prevailing tones are red and blue and gold, with greys and other neutral tints to give harmony to the scheme'. *The Builder* wrote that the scheme was

> an essay full of promise with much suggestive treatment, considerable imagination and, on the whole, exceedingly good colour ... the work is ... of considerable magnitude and importance, on a wholly different scale of effort from the diminutive chapel. Yet of the two it is the more successful: both intention and execution show marked advance ... the colour is stronger and richer, faults of drawing are less obtrusive; and the decorative imagination is both fuller and more certain.

For this critic 'Mrs Traquair excelled, no less, in qualities of decorative sense and appropriate imagination' and the 'rendering of her theme is fresh and modern'.

Traquair was now formally acknowledged by the British art establishment. Her work was 'modern' in the frankness of its portraiture, its assimilation of a Renaissance schema, and, not least, its decorative values. Long before reviews appeared in England, Traquair's 'work in progress' had become a local talking point. Working on the south wall in late October 1889

she was visited by Walter Crane, in Edinburgh with fellow artists, designers and architects to debate the value and place of the visual arts in society. The second meeting of the National Association for the Advancement of Art and its Application to Industry was held in the Scottish National Portrait Gallery. Delegates were taken to view the Forth Bridge ('that supreme specimen of ugliness', blasted William Morris), then nearing completion. Traquair's two painted rooms, the second still less than a third complete, were showpieces of the new public art. While Traquair is not known to have attended any meetings, she would have been aware of the discussions and met a number of visiting delegates in her two buildings and through Gray, Baldwin Brown, Geddes and many others.

Crane sought her out and would record his time with 'Mrs Traquair, the distinguished artist and craftswoman' in his memoirs. The year in which she completed her Song School work he wrote in *The Claims of Decorative Art* of how 'all really great works of art are public works – monumental, collective, generic – expressing the ideas of a race, a community, a united people, not the ideas of a class'. These were ideas which, together with debate on the importance of the crafts including sculpture within urban architecture, had been argued in Edinburgh. Morris had called for a new 'co-operative art of life' in which artists were as good craftsmen as possible and worked in brotherly harmony, 'each for all, and all for each'.

The turn of the decade was important not only for Traquair, but more generally in the establishment of nationwide Arts and Crafts. The year 1888 had seen the London launch of the Arts and Crafts Exhibition Society to showcase studio practice and manufacture. In 1893 the Society set out its developed creed in a book of essays and *The Studio* journal was first published in London. Promoting individuals, exhibitions and interior design, it fostered an international taste for Arts and Crafts design and would illustrate work by Traquair.

Throughout the 1890s Crane, the socialist designer, exerted a considerable influence on international design development. In Edinburgh he had given a general paper on 'Design in relation to Use and Material', and in 1892 his book *The Claims of Decorative Art* engaged with the place of craft and design within society. For him, unity of subject and style was as vital in a mural decoration as in book decoration. His book *Of the Decorative Illustration of Books Old and New* (1896, a reworking of his

[21] **Binding on F.G. Stephens's**
Rossetti (London, 1894) 1898

Morocco 27.5 x 19 cm

A typical binding from the late 1890s, the design was impressed in bas relief into the plain morocco-bound book. Most designs reflected images from the text, but here Traquair adapted a detail from her recently restored children's hospital painting [11]. The binding has

National Museums Scotland, Edinburgh

1889 Society of Arts lectures) aligned the past and the present in terms of book production. Writing of medieval manuscripts he referred to the illuminator's graphic power and artistic sense, where 'close imitation of nature and dramatic incident' were allied to 'imaginative beauty and systematic organic ornament'. Exactly what Crane and Traquair talked about that autumn day, or days, in 1889 is not known, but, given their shared interest in decoration, and especially in books and manuscripts old and new, it is not hard to imagine their discussion.

In late 1892, probably on Crane's recommendation, Traquair was asked to exhibit a book at the World's Columbian Exhibition in Chicago, USA the following year. The book – collotype photographs of an 1890–2 illumination of Tennyson's *In Memoriam* – was bound in morocco leather, embossed to her own design and set with two silver Celtic clasps manufactured by the Edinburgh silversmith J.M. Talbot. The original manuscript had been commissioned by the civil servant, inventor and craftsman Sir Henry Hardinge Cunynghame (1848–1935), a friend of Holman Hunt and for whom she also copied *The Dream*. Her embossed cover was worked 'blind' in an Italianate figural style and reproduced some of the manuscript imagery. Tennyson's poem doubtless brought back memories of images of life and loss in her chapel.

This type of leather bookwork would develop into the 'Edinburgh binding' style worked with women friends during the years 1897 to 1900 [21]. The women worked alongside one another on their covers in the Dean Studio, a disused church in Lynedoch Place where Traquair had taken a professional studio in 1890. Her friends included Annie Macdonald (1849–1924), wife of Edinburgh actuary William Rae Macdonald, who was introduced by John Miller Gray. In 1897 Annie Macdonald would be instrumental in establishing the nationwide collective of the Guild of Women Binders to which this mixed group of amateur and professional craftswomen was affiliated.

However, with the exception of an illuminated address commissioned in 1890 for presentation to Louis Pasteur, Traquair's page work did not yet figure in the international arena [22]. Her illuminated manuscripts took two forms. The popular illuminated page for presentation addresses was the more formal, while single or bound page illuminations of poetry were commissioned by family or through friends. In some respects the early 1890s were still years of artistic experiment. Traquair studied the illuminated books of Blake, the illustrations of John Flaxman, and Italian and

French manuscripts of the later fourteenth and fifteenth centuries. She was looking for decorative features but also studying the correspondence between visual and literary expression. This first surfaces most effectively in the sonnet *Willowwood* from Rossetti's *The House of Life*, which for her was a modern counterpart to Dante's *La Vita Nuova*. In *Willowwood* she introduced a fluttering of Italianate gold leaves to enclose the text.

The maturing of Traquair's ideas in the early 1890s depended on both an advance in skill and new texts with which to work. She began to read Edmund Spenser's *The Faerie Queene*, a text also popular with Crane. In the saga of the Red Cross Knight of Holiness she found an epic, symbolic voyage towards truth, a parallel with John Bunyan's *Pilgrim's Progress*. Her illuminated address for Pasteur had illustrated a knight slaying the beast of human and animal suffering, a translation of Spenserian imagery. In May 1890 she was commissioned to decorate a cabinet with seven panels of which she writes, 'I am trying to get in [*sic*] Spenser story of the Red Cross Knight'. A second cabinet dated 1893 has survived, commissioned by Margaret Barbour, sister of Jane Whyte, for their brother Hugh [23]. This illustrates eight scenes from *The Faerie Queene* with both commission and choice of text underlining the importance of this family's friendship to her art. These were years when she engaged in a range of professional decoration. In late 1892 she painted a circular canvas for the drawing room ceiling of J.R. Findlay's country house at Aberlour [24], and in 1893–4 painted another for William Moss's home, Burnthwaite, near Bolton.

Traquair relied on her housemaids to prepare meals for guests

[22] **Address illuminated for Louis Pasteur 1890 (detail)**

Ink and watercolour on vellum

Traquair's page prefaced eighty-four pages of signatures of scientists, 'friends and admirers in the British Empire and America', as a 'token of respect and gratitude for his great services to Science in the alleviation of Human and Animal Suffering'. While the page was worked in medieval style, her key image of the Knight of Science piercing the beast of suffering is in a more modern idiom. Ever the eclectic artist, she also refers to Michelangelo's design for *The Battle of Anghiari* in hands reaching out of the waters and to Blake's woodcut for Virgil's *Pastorals* in the scale and windswept form of the tree.

Pasteur Institute, Paris

and sometimes even show visitors artwork. As a professional she seems to have been seldom at home, and certainly never enjoyed the social demands of entertaining. She referred to 'being brave, having about 9 little dinners, just made our maid do it'. Having a professional studio, especially when the light was too poor for mural work, allowed Traquair space to work on decoration and the quiet to develop illumination. Compiling ninety individual illuminated vellum pages of Tennyson's *In Memoriam* for Cunynghame in 1890–2 had been the first true test of dedication to this craft. While inventive, many of her pages were conscious reflections of historic medieval (especially marginalia) and early nineteenth-century work. Some pages made reference to Blake's own graphic work – such as his title page for *The Marriage of Heaven and Hell* and *The Inscription over the Gate of Hell*. She again used his angel quartet from *The Book of Job* in 1892.

In Memoriam was a popular poem concerned with the process of bereavement and the survival of the soul, a topic with which Traquair had already engaged in other crafts. Further texts began

A circular canvas was decorated with 'kicking putti' for the country house of J.R. Findlay at Aberlour, Moray, in late 1892. Traquair was asked to include portraits of his daughters Grace, Florence and Dora. Although this essay in Italianate decoration was exhibited at the 1893 Royal Scottish Academy, and photographed, it has not survived. Findlay's Edinburgh residence in Rothesay Terrace was close to the Dean Studio where the Findlay girls probably sat to the artist.

National Library of Scotland, Edinburgh

to attract her attention. Robert Browning's poem *Saul* was illuminated for the Macdonalds between August 1893 and June 1894. In November of that year she purchased a copy of William Morris's *Defence of Guinevere* which, with *The Song of Solomon*, she would illuminate in early 1897. Rossetti's *The Blessed Damozel* was worked between January 1897 and June 1898 and Sir Thomas Browne's *Religio Medici* at roughly the same date, published versions of which she had bound in leather for embossing.

In 1892, in consultation with her brother William, Traquair decided on a poet and a work to illuminate in depth over the next few years. *Sonnets from the Portuguese* by Elizabeth Barrett Browning (1806–1861) would take Traquair almost five years [25]. This was her first illumination to be substantially written up in London. *The Studio* special winter number of 1897 secured a place for her as a leading British Arts and Crafts worker and not only a muralist. The author of the article 'Beautiful Modern Manuscripts', Margaret Armour, married to the graphic artist and calligrapher William Brown Macdougall, was already an Edinburgh correspondent for *The Studio*. She had written an article 'Mural Decoration in Scotland, part 1' on the recent Celtic work by artists John Duncan (1866–1945) and Charles Mackie (1862–1920), members of Patrick Geddes's circle, at Ramsay Garden, Edinburgh, and Pitreavie Castle in Fife. A writer with a European perspective on the arts, she now placed leading modern illuminators in a historical perspective. She singled out Traquair and Edmond Reuter of Geneva as 'pre-eminent' in the modern field.

In the early 1890s, as William Morris was setting up his Kelmscott Press in Hammersmith and once again purchasing major medieval illuminated manuscripts, his article 'Some Notes on the Illuminated Books of the Middle Ages' appeared in *The Magazine of Art*. The balance of old and new in Morris's life and work was echoed in Traquair's world. She was quoted by Armour as praising thirteenth- and fourteenth-century illuminated work, 'the smallness of the work making it all the more necessary for the worker to limit himself to the vital points with a stern negation of non-essentials; all decorative art, of which illumination is but a department, being in its very nature an accompaniment, as an instrument is to the voice.'

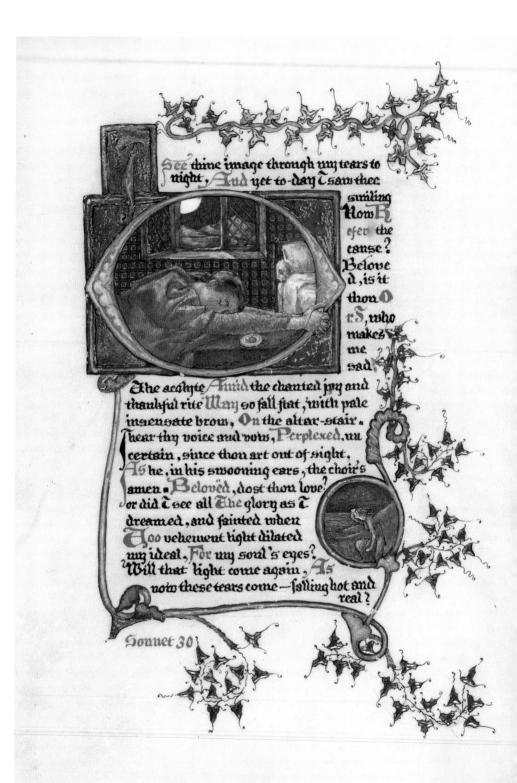

See thine image through my tears to-
night, And yet to-day I saw thee
smiling. How Refer the
cause? Belove
d, is it
thou Or
I, who
makes
me
sad?

The acolyte Amid the chanted joy and
thankful rite May so fall flat, with pale
insensate brow, On the altar-stair.
I hear thy voice and vow, Perplexed, un
certain, since thou art out of sight,
As he, in his swooning ears, the choir's
amen. Beloved, dost thou love?
or did I see all The glory as I
dreamed, and fainted when
Too vehement light dilated
my ideal, For my soul's eyes?
Will that light come again, As
now these tears come—falling hot and
real?

Sonnet 30

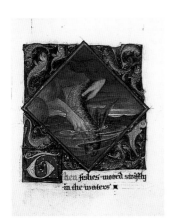

Sonnets from the Portuguese is striking in its modernity. In her interview Armour brought out Traquair's increasingly intuitive approach and her pleasure in her materials. She deliberately avoided colours with body but rather used, as she wrote to Willie Moss, 'pure transparent colour' with hatching of yellow and blue for green. Apart from hatched work, she also used minute 'particles' of pure colour side by side in a microscopic, neo-impressionist manner. It was all intensely painstaking work, but no more so than her ongoing illustrations for her husband's research papers. In her version of the *Sonnets*, poems expressing the growth of love, colour gradually develops its own language, from experimental combinations to a confident intensity. By the mid-1890s her images had an unrivalled power.

Completed in January 1897, *Sonnets from the Portuguese* was sent to Thomas Cobden Sanderson's Doves Press in London for binding in green calf with gold tooling before being presented to her brother William. It would be treasured by him and his family. She had already shown selected pages in a major charity Arts and Crafts exhibition arranged by Glasgow School of Art headmaster, Francis Newbery, in the Queen's Rooms, Glasgow, in 1895, and soon other commissions followed, notably an exquisite little book for Hugh and Margaret Barbour of her Creation images from the Song School border decoration [**26**]. This was warmly received, with Traquair responding that it was

> *a great pleasure to me to think my work is with one who*
> *feels so much for it and so full understands it … in as far as*
> *I can, I let the day produce its own expressions though I try*
> *to have the execution as good as I can do … our thoughts*
> *are scarcely our ruin – bad workmanship is altogether.*

Illuminated addresses were also requested, of which two were for presentation to Alexander Whyte [**13**]. The next five years would also see her working on Rossetti's *The House of Life*, again for her brother, and Dante's *La Vita Nuova* for Sir Thomas Gibson Carmichael (1859–1926).

The House of Life was illuminated between 1898 and 1902 [**27**]. This sequence of poems is concerned essentially with the sharpness of love and loss, and eventual acceptance of the force and effect of time. Rossetti expresses the intensity of a series of defined moments to which Traquair responded with images. The poems present a non-religious view of life, where the 'beloved' is the focus of 'the meaning of all things that are'. It may be said that *The House of Life* is a companion to (and, in its secularity,

the antithesis of) *In Memoriam*. The poems and images were responses to experience, and as such were now integral to Traquair's world. She acknowledged in a letter how, for an artist, 'at time strong discords, passions which have not yet found their harmonies rush in, but it is all music… at the foundation of all things the great Eternal harmonies for every sound …'.

It is not difficult to see why she was attracted to the work of Blake, Tennyson, the Rossettis, the Brownings and Dante. All were poets who dealt intimately with the precious moments and dimensions of life. Their texts were rich in imagination and the joys and pains of memory. Some particularly beautiful, intense images were worked in both illumination and as easel paintings, providing different contexts and scale for her ideas [**28**]. In a letter she referred to the poet Christina Rossetti's view of the committed 'tired and lonely' artist. Traquair, in agreement with her, wrote of the artist's essential intensity of expression, the

[27] Sonnet 45 from *The House of Life*
1898–1902

Ink, watercolour and gold leaf on vellum
Page size 19.1 x 15.7 cm

The House of Life was the text by Rossetti to which Traquair turned most frequently for inspiration. *The Vase of Life* was illuminated in 1901 and is an example of the poetic sensitivity of her work. Colour was used 'side by side in small particles', thus bonding Pre-Raphaelite poetry with modern art's move into synthesism. A related modern approach was adopted in later sections of her Catholic Apostolic Church.

National Library of Scotland, Edinburgh

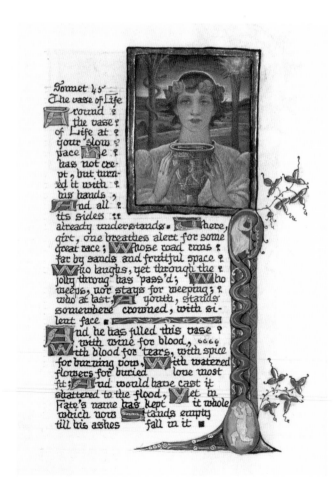

[28] *Love's Testament* 1898

Oil on canvas 53.3 x 35.5 cm

The painting immediately reworked Traquair's illumination of Sonnet 2 of *The House of Life*. Traquair was ever conscious of the potential problems of rescaling design. Here, colour and image were carefully reconsidered for transfer into the medium of easel painting.

Private collection

'spilling of one's blood ... it does not matter how one does it, but to live life at one's *highest*, feel one's keenest'. For her, a lover of nature, these could match 'the setting sun, the deepening shadows, the flash of the great green eye and the flow of the crimson stream through the grass'. This keenness for perfection also reflected her reading of Walter Pater, notably *The Italian Renaissance: Studies in Art and Poetry* (1873) with its celebrated call to 'burn always' with a 'hard, gemlike flame'. As Pater had written that 'not the fruit of experience, but experience itself, is the end', so Traquair's work of the 1890s narrated moments of 'experience' in her jewels of book art. Yet these were also companion pieces to large-scale art and craft. Worked in parallel to *Sonnets from the Portuguese* and *The House of Life* were her twin epics of experience – the decoration of the Catholic Apostolic Church (now the Mansfield Traquair Centre) in Edinburgh and the embroideries, *The Progress of a Soul*.

Canzone terza.

Li occhi dolenti per pietà del core
hanno di lagrimar sofferta pena,
sì che per vinti son rimasi ormai.
Ora s'io voglio sfogar lo dolore,
che appoco alla morte mi mena,
convenemi parlar traendo guai.
E perchè mi ricorda ch'io parlai
della mia donna, mentre che vivia,
donne gentili, volentier con vui,
non vo' parlare altrui,
se non a cor gentil che 'n donna sia;
e dicerò di lei piangendo, pui
che se n'è gita in ciel subitamente,
e ha lasciato Amor meco dolente.

Ita n'è Beatrice in l'alto cielo,
nel reame ove gli angeli hanno pace,
e sta con loro, e voi donne, ha lasciate.
Non la ci tolse qualità di gelo
nè di calor, siccome l'altre face;
ma sola fu sua gran benignitate.
Chè luci della sua umilitate
passò li cieli con tanta virtute,
che fe maravigliar l'eterno Sire,
sì che dolce desire
lo giunse di chiamar tanta salute,
e fella di quaggiuso a sè venire;
perché vedea ch'esta vita noiosa
non era degna di sì gentil cosa.
Partissi della sua bella persona
piena di grazia l'anima gentile

3 Innocence and Experience

Walter Pater's analysis of the Italian Renaissance had identified it as a period of humanist culture in which the intellect and the imagination held equal sway. Through the 1890s Traquair worked towards what Pater referred to as 'wisdom, the poetic passion, the desire of beauty, the love of art for its own sake'. While not turning her back on the responsibility of the artist to society, she increasingly sought in her work a synthesis of art disciplines, cultures and a range of secular and religious imagery to echo the complete experience of life.

Her Rossetti and Dante manuscripts were to be completed in 1902, the same year as *The Progress of a Soul*. Both manuscripts and embroideries were concerned in different ways with the journey of the spirit. Her painted pages made visual reference to Rossetti as both poet and painter and to Dante. They usually also contained thumbnail portrait sketches of her patrons [**29**]. In *La Vita Nuova* Lady Gibson Carmichael was portrayed as Beatrice. Traquair also modified her page decorations to reflect the decorative style of the period in which the poetry was written, and her colour varied, as ever, in response to the emotion expressed by the poet.

In her illuminations of the 1890s, mural work and most especially the *Progress of a Soul* embroideries, Traquair was effectively creating her own 'book of life'. The decorations of the Catholic Apostolic Church in East London Street, Edinburgh, encompassed life's spiritual experience within a sacred, Christian context. Created for a prosperous congregation whose nineteenth-century liturgy fused modernity with ecclesiastical traditions from East and West, it further encouraged an interdisciplinary approach to art and craft.

The commissioning of the Catholic Apostolic Church scheme was driven partly by Traquair herself and partly by the leaders of the current city culture. In April 1892, as she was completing her decoration of the Song School, the executive committee of the Edinburgh Social Union discussed the question of commissioning a further decoration scheme from her. Gerard Baldwin Brown, keen to establish a local mural school, even wished her to

[**29**] *La Vita Nuova* 1899–1902

Ink, watercolour and gold leaf on vellum
Page size 19.2 x 15.2 cm

The commission from Sir Thomas Gibson Carmichael for an illumination of a favourite Dante work cemented Traquair's friendship. As she included portraits of her brother William in *The House of Life,* so she here included her new patrons. Sir Thomas is shown in front of his home, Castlecraig. The manuscript style is animated in response to Italian manuscripts.

Private collection

lead a 'practical class for the decoration of some hall'. Union secretary, Ella Kerr, mentioned the new Catholic Apostolic Church in East London Street (the address was changed recently to Mansfield Place) as 'having been specifically designed for mural decoration'. Its architect, Robert Rowand Anderson, had indicated nave wall decoration in early published drawings but to date this building, erected in a neo-Norman style, 1873–6, and Transitional Gothic, 1884–5, has been left plain and unadorned.

However, this building, the size of a small cathedral, had not been the first choice of the Social Union. Discussions had initially focused on the entrance hall of the new Scottish National Portrait Gallery, a national building. Traquair rejected the idea. The provision of a frieze of historical figures was simply not her type of work. Willing to work once more with the Social Union, she suggested 'some portion of St Giles'. Although this idea found favour with the minister of St Giles' Cathedral, Dr Cameron Lees (five large bays on the north wall were identified, and decorator James Clark was once more lined up to prepare the walls), the commission did not materialise due to lack of support from the cathedral's Kirk Session. The Social Union discussed a new building throughout the spring of 1892, only fixing on the Catholic Apostolic Church in July.

Writing in *The Studio* in 1905, A.F. Morris summed up Traquair's philosophy and her response to this vast building. Seemingly undaunted, she felt she could work with music and concepts of harmony on a grand scale [30]. The space, unrestricted by side aisles, was glorious and further transformed during Catholic Apostolic services by its many celebrants (known as angels, priests and deacons) dressed in beautiful, rainbow-hued vestments moving and interacting within the unusually deep chancel. With its modern, rich music tradition, a service was an affecting, and at times transforming, experience for the congregation. Seemingly Traquair was also similarly affected. 'Imagination', Morris wrote:

> is the touch of nature that gives the kinship to poetry, music
> and painting, and each in its turn inspires the other. Music
> has had a great influence on Mrs Traquair's career. Espe-
> cially has it played its part in her mural designs; indeed it
> was the prime factor in the decoration of the Catholic and
> Apostolic Cathedral in Edinburgh, for straying into the
> building one day, while service was in progress, the swelling
> notes of the organ resounding through the church so worked

INNOCENCE AND EXPERIENCE

*upon her, that when the prayers were over she walked up to
one of the Deacons and, without pause or ceremony,
assailed him with the remark 'I want to paint these walls'.
Being well-known, her demand met with courteous if
amused attention, and a slight discussion as to monetary
and other difficulties ensured, which she concluded by say-
ing, 'Well! if I am to paint these walls, no one in Edinburgh
can prevent me: and if I am not going to paint them, no one
in Edinburgh can make me!'*

There is probably much truth in this account of Traquair's burn-
ing desire to tackle such a spectacular interior. She wished to
respond here not only to the words of the Bible, but to the electri-
fying dynamics of this extraordinary church. By October 1892 her
commission had been successfully negotiated through the Social
Union. In contrast to the Song School work, she was given wood-
en scaffolding: 'delightful, so comfortable, just like the artists
have in Paris', she wrote to Willie Moss. The commission would
take her the best part of nine years, from spring 1893 to December
1901.

The liturgy of the Catholic Apostolic Church drew on the
Eastern Orthodox, Roman Catholic and Anglican churches in
an anticipated celebration of the Second Coming of Christ. Ser-
vices involved the use of lights, incense, ointments, holy water
and chrism. The charismatic and the sensual thus partnered and
encouraged the spiritual. The demands on Traquair, therefore,
would be great, but equally here was a unique opportunity to give
full rein to her imagination. While she was obliged to map out her
ideas, her way of working, as Scottish National Portrait Gallery
curator James L. Caw would write in 1900, was largely intuitive,
'the spontaneous efflorescence of her imagination, her religion,
and her love of beauty'. Caw referred to her mural work where she
was reported to have made 'no preliminary sketches or designs,
but has wrought direct upon the walls, following the promptings
of her instinct and mood. She waits until an idea shapes itself in
colour and line in her mind's eye, and then transfers it to the walls
at once, thus retaining the vividness and freshness of the concep-
tion.' [31] Despite this account of Traquair the expressionist, she
of course knew where she was going in her art. A broad scheme
would be worked out, but the final means of expression, the detail
and especially the colours would be of the moment. She aimed to
achieve perfection. Changes were made within hours or days –
sometimes necessitating (in the case of gesso work) replastering

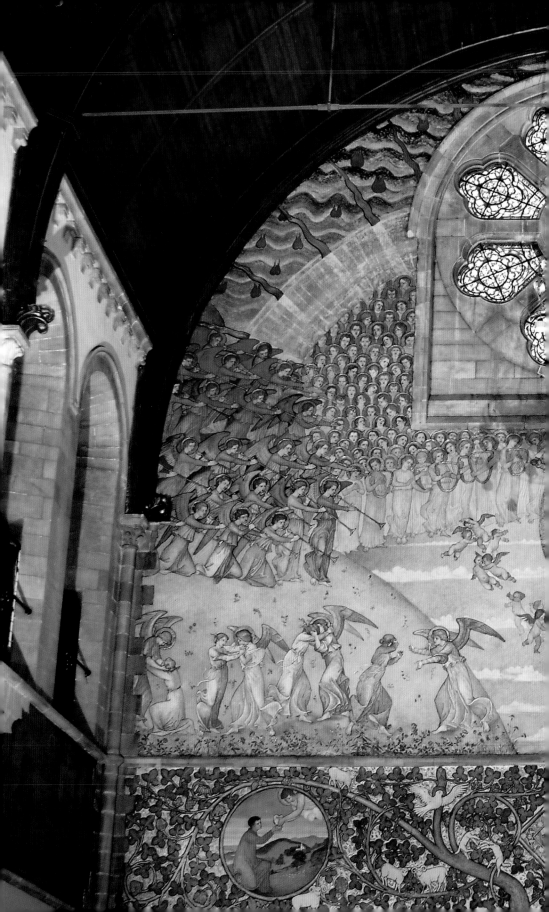

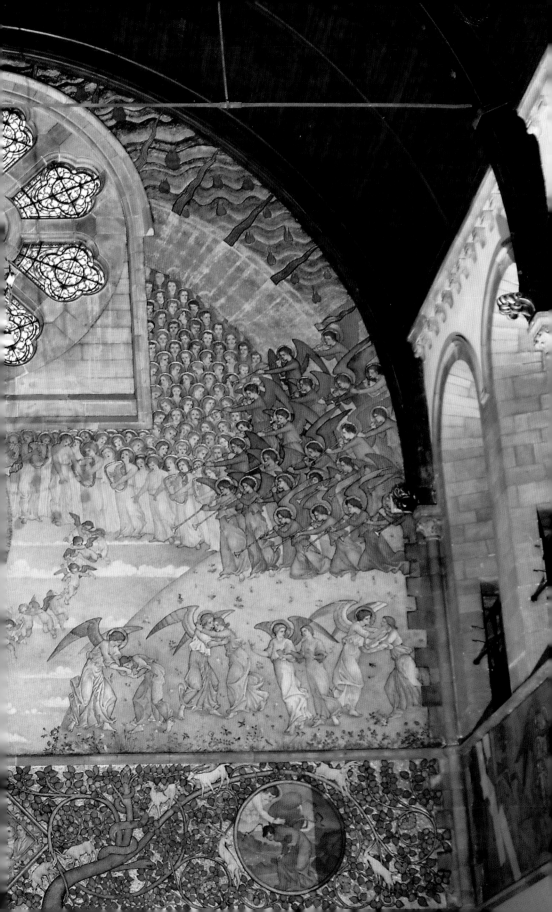

[32] *The Great Cherubim,* chancel arch
1893–4 (detail)
These cherubim on the north section of
the arch represent the evangelist and
apostolic models of ministry of the
Catholic Apostolic Church.

fresh incisions and new application and moulding. Figures might
even be repositioned. It is unsurprising, therefore, that only a few
preliminary designs for figural groups and a decorative frieze
study have survived, and these differ from the realised artwork.

The commissioning of such a vast scheme, albeit through the
intermediary of the Social Union, was firm recognition of her
status by the early 1890s. An outline for the decoration was
agreed in advance with the deacons of the church. Mapped out in
general, it was decorated in clear stages to allow uninterrupted
use of the building. She was responding to their needs – to
illustrate the key images of their faith and complement the words
of their liturgy and, not least, their music.

The first, and for her patrons the most important section (and
a real test of both her physical and artistic strength), was the
great chancel arch which faced the congregation. This was
twenty-two metres in height. Above the aisle archways she
integrated the fine and decorative arts through the use of oil
paints next to the gilded gesso used for the haloes of the Four
Living Creatures (Ezekiel 1: 5–14 and Revelation 4: 6–8). She
had previously painted smaller creatures on the Song School
west wall to accompany her four Blakean angels. In both
schemes the creatures, who 'day and night never cease to sing,
"Holy, holy, holy, is the Lord God Almighty"', were positioned
either side of a music source, whether organ or choir. Gilded
gesso was also used in the figures of four cherubim immediately
above [32]. These symbolised the four modes of ministry of this
church (the evangelist, the apostle, the prophet and the pastor)
and two occupied either side of the arch. The cherubim, each in
the colours of his ministry (red, gold, blue and white, thus
relating to the vestments worn by the priests), were washed in a
rainbow which crossed the chancel to touch the tabernacle.

Across the top of the arch Traquair painted her first image of
the worship of heaven by the Perfected Church, again using
gesso and gold leaf to give the trumpets and haloes of angels and
the thrones of the seated elders reflected natural or artificial light.
At the uppermost range she had short-term assistance from the
young John Fraser Matthew. Matthew was the first architect to
be articled to Robert Lorimer and would later become a partner
in his firm.

This first wall was partnered by the west wall, which she
worked on last in 1900–1 [30, 33]. Having painted smaller
sections – the chancel aisles from 1895 and a series of illustrative

INNOCENCE AND EXPERIENCE

scenes from the Old and New Testaments in the nave from 1898 – Traquair again tackled a wall more than twenty metres in height. She here provided the requested focus for the celebrants in the chancel and created an image to uplift the congregation as they left the building. A deep border provided a rich base for the scene of the Second Coming. Vigorously moulded in gesso by her small fingers, then hand gilded, the border frieze was set with three scenes illustrating the love of God. A shepherdess on a hillside, dotted Venetian style with a church and sheep, receives a golden heart from an angel, an angel releases a heavy-laden man of his burden, and, in the central Pentecostal scene, the apostles and Mary Magdalene are represented by the church deacons and what appears to be a self-portrait – a final 'full stop' for the entire building.

The dense richness of the border was designed as a clever visual foil for the Second Coming, where Christ dispensing 'the grace and blessing of Almighty God' is surrounded by a semi-circlet of putti set against a beautifully airy, Venetian blue heaven studded with cumulus clouds. With angels welcoming souls to heaven and bands of massed angel trumpeters, she also painted a

[33] **West wall, Catholic Apostolic Church 1900–1 (detail)**

This detail illustrating 'the worship of all creation' demonstrates Traquair's range of styles, from Pre-Raphelite to semi-expressionist, and her interest in synaesthesia. The vibrant colour of the angel wings is sound in vision.

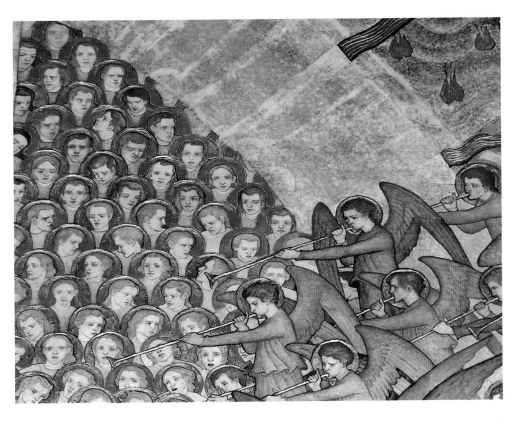

[34] *The Awakening of the Ten Virgins,*
south chancel aisle, Catholic Apostolic
Church, 1895–6

One of several illustrations of the parable
of the ten virgins, this scene is symbolic of
the awakening of the spirit.

[35] East ceiling, south chancel aisle,
Catholic Apostolic Church, 1896
(detail)

Illustrating the final three days of the
Creation, Traquair used poetic descrip-
tions from Psalm 148, rather than
Genesis. Portraits of the congregation
and their families represent 'kings of the
earth and all people'.

vast choir of rejoicing souls which, as in the great arch, made up
the great multitude of the Redeemed 'which no man could
number'. Many of these were portraits of the congregation [33].
Right at the top is a sea of glass mingled with fire, executed in an
astonishingly free semi-expressionist manner.

In painting these two large walls, Traquair could quickly
cover large areas although, as she complained, she was depend-
ent on good light conditions and repainting was occasionally
necessary. She wrote to Willie Moss, 'I go to my church, mount
my scaffolding and sit and groan for light, light of the present or
of other days, but all in vain, no light cometh. Colour put on one
day is all wrong the next.' As in the Song School she worked on
prepared dry plaster and used oil colours thinned with her paste
of turpentine and wax over a dry, thickly painted white ground.
Highlights were created by wiping away colour to reveal the
paint layer beneath.

The wider south aisle had been specifically designed as a
chapel for services, which were held four times daily. This second
section was painted immediately after the great chancel arch.
From 1895, working on smoother plaster similar to that of the
Song School, she illustrated the parable of the ten Virgins
(Matthew 25: 1–3) [34]. Following a second visit to Italy in
April of that year she consciously adopted an Italianate style,
running the scenes round the walls to complete the sequence in
the north aisle in 1897. Below she provided a decorative border,
much deeper than that of the Song School. Floriated and gilded,
it was set with scenes from the life of Christ, many of which,
such as an Annunciation on the west wall, directly related to the
parable illustrated above.

From the start this chapel was meant to induce in the worship-
per a state of spiritual awareness. Traquair was working on a
different scale here. Away from the nave she could also afford to
personalise her images, and chose to illustrate the spiritual
journey through a parable using female figures. She sketched in
landscape backgrounds to each, from the Wicklow Hills in the
first to Scottish Borders country in the second and third. The
awakening of the spirit on the south wall, where an angel sounds
a gilded trumpet, was central to the entire decoration, accompa-
nied by scenes below of the entombment of Christ, Christ with
the sleeping disciples and, once more, the three Marys at the
empty tomb. Other small panels to the sides included the vision
of Habakkuk and a girl rapt in prayer by night. Another border

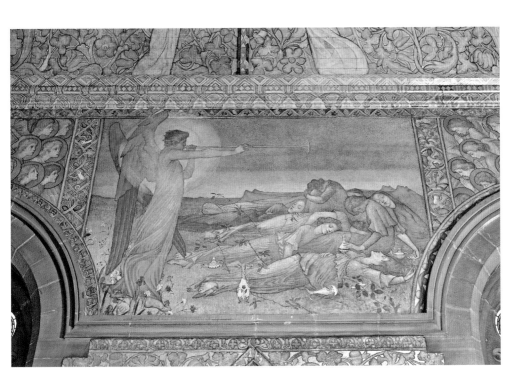

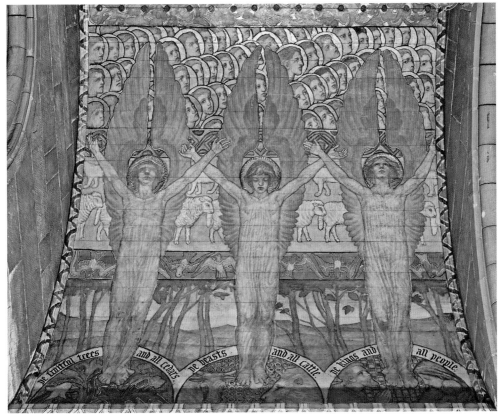

ye fruitful trees and all cedars ye beasts and all cattle ye kings and all people

medallion illustrated doubting Thomas. On the wooden vaulted ceiling above, angels tended flowers in paradise, passing up and down as ministering spirits.

At south chapel services candles were used on the altar to the east. The roof decoration, therefore, used not only vivid colours but also gold and aluminium leaf applied on worked gesso, designed to shimmer by candlelight. To illustrate the six days of Creation (Psalm 148) Traquair provided six red-winged seraphim with raised arms similar to those in the Song School. Arranged three to each side of the roof, each seraphim stands against bands of natural detail [35]. The appropriate phrases were lettered onto lunettes at their feet: the 'sun and moon', 'mountains and all hills', 'dragons and all deeps', 'fruitful trees and all cedars', 'beasts and all cattle', 'kings and all people'. At ceiling height semi-abstract patterning, crude relief work and strong colours were freely used. Several of the angels are simply composed of loose brush strokes, which can be read as faces only from floor level.

In 1898 *The Studio* would comment that the south chapel in its 'art opulent with the colour and warmth of the South' made the visitor catch his breath 'at surroundings so rich and so little anticipated. For the whole Chapel scintillates and glows like a jewelled crown. Bright blossoms and foliage inlay upon the gold background their curving spirals of rubied flower and rich, broad leaf.' This was seen as cold, grey Edinburgh's answer to Florence. Now Scotland also could celebrate the 'freshness of art's springtide'.

Traquair concluded her parable in the north aisle. Here life's journey towards resolution, or Christian redemption, was celebrated in a number of ways. Beyond the main scenes from the parable are complementary illustrations taken from Old and New Testament scenes chosen to encourage the spectator to walk 'in the true way'. Celebratory scenes of arrival and reunion dominate the central north wall. In one scene two mortals kiss, watched by

[36] Wall and ceiling decoration, north chancel aisle 1896–7 (detail)

At the lower level, where ceiling meets wall below, a line of angel heads provides a perfect link between the two parts of the decoration – one of pattern and one of illustration.

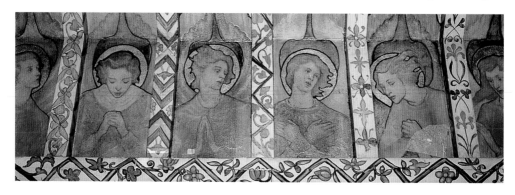

INNOCENCE AND EXPERIENCE

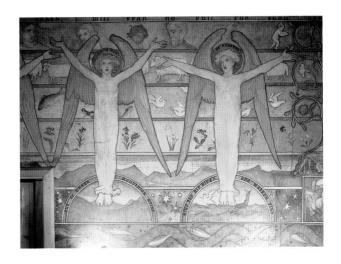

[37] East wall, Chapel of the Royal
Hospital for Sick Children, Edinburgh
1897–8 (detail)

Traquair's new chapel walls were simple
in order to celebrate childhood. Large
new sections had six angels against six
horizontal bands representing the days
of Creation, with her husband Ramsay
and daughter Hilda as 'mankind'. The
serpent of eternity, surrounded by souls
'mounting up to God … like thin flames'
(Rossetti's *The Blessed Damozel*,
illuminated by Traquair 1897–8) forms
the lower border. A door to the left,
forced through in the 1970s, meant the
removal of a mural section.

NHS Lothian, University Hospitals Division

angels, an image used simultaneously in *Sonnets from the
Portuguese*. It illustrates the text 'mercy and truth are met to-
gether, righteousness and peace have kissed each other' while
below, in another image of mystic union, angels and mortals
kneel either side of a Virgin and Child. Always, however, the
purely decorative was as important as the illustrative. Traquair's
arabesque border patterning emphasised the feminine. James
Caw referred to the 'wonderful polychromatic decoration' of the
sloping roof [**36**]: 'Unlike almost all modern designers touched
with Celtic influence she uses them in no imitative way, and
enriches the result by her own deep sense of beauty and original-
ity of observation.' What Traquair made of Caw's remarks is
unknown, but in an undated letter she expressed horror at the
prospect of an article on her, a 'more terrible thing than decorat-
ing a cathedral'.

 As she painted these scenes in 1896 Traquair was also work-
ing once more on her children's hospital chapel decoration, this
time on a new site. The original Lauriston Lane Hospital had
been demolished following a typhoid outbreak, but, following a
petition to save her murals, some walls were successfully trans-
ferred to a new building at Rillbank, south of the Meadows [**37**].
Seraphim, similar to those in the Catholic Apostolic Church on
the south aisle east ceiling, were painted against six bands to
represent the days of Creation. In this second chapel she included
portraits of her husband Ramsay (who was aged about fifty-
seven) and her daughter Hilda (aged about seventeen) to repre-
sent 'young men and maidens, old men and children', as she
wrote in her published guide to the chapel.

[38] Decorative panel at Kellie Castle, Fife 1897

Oil on canvas 195.5 x 171.5 cm

One of several domestic decorative panels from the 1890s, this painting, worked in situ, was a secular adaptation of the first scene in the south chapel at Catholic Apostolic Church. It is an exercise in decorative colour and 'feminine' drawing-room imagery. The figures reflect Traquair's interest in the art of Botticelli.

National Trust for Scotland

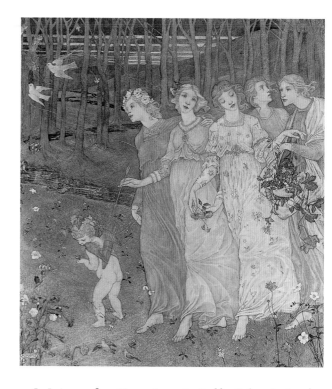

In January 1897, Traquair was invited by Robert Lorimer's brother, the artist John Henry Lorimer, to consider two decorations for the drawing room in his father's Fife home, Kellie Castle, for a fee of £100. She spent a night in July with them and, according to John Henry's mother, decided on 'a procession of girls following a wee Cupid, a high horizon line and tree stems going up high against the sky and flowers *poudré* all over' [**38**]. Traquair spent the month of August at Kellie where the Lorimers were much taken with her, considering her 'delightful' and 'solid on the road'. She rose early, and would go for a bicycle ride, take a walk in the garden or read until breakfast, working through until 1.30pm and, after lunch, painted until six o'clock. 'At lunch and tea she keeps on her long linen garment and her little velvet cap ... she has charming eyes and much expression', wrote Mrs Lorimer to her daughter.

The overmantel painting was a decorative reworking of the first scene from her *Parable of the Ten Virgins* in the Catholic Apostolic Church. The background landscape to each was important. At Kellie it was entirely local, a setting which is still easily recognisable, while in the church the Wicklow Hills provided an equally appropriate symbolic setting – in that case the start of her own journey through life. Here the scene is simply a

INNOCENCE AND EXPERIENCE

decorative one of maidens setting out on the course of love, and engaging with Cupid.

By this date two panels in her *Progress of a Soul* embroideries were complete. She had conceived these within six months of starting the decoration of Catholic Apostolic Church and they were to be equally ambitious. She decided on four panels, a popular symphonic format traditionally used, and especially in the 1890s, for such secular subjects as the four seasons. Like Pierre Bonnard's painted panels *Women in a Garden* (which Traquair, who made several visits to Paris, may have seen at the Salon des Indépéndents in the spring of 1891), her embroideries were intended to function as both a practical domestic draught-screen and works of art [39]. Traquair also focused on a single figure in each tall panel, surrounded by an arrangement of colours and textures related to nature. Unlike Bonnard, however, she united her panels through episodic, sequential imagery based on a single character. Such a focus on the experiences of the individual related, of course, to her illuminated pages, but also to current European writing on aesthetics, where the potential of the psyche, or soul, was being explored. Traquair would have been influenced here by her discussions with Baldwin Brown, a historian who especially valued new German writing. In 1892 she had studied examples of what she called 'designings' at Edinburgh University – 'Greek, Keltic [sic], Gothic, Eastern, Egyptian and so on'. Her embroideries are at once applied art objects, each one signed and dated, and part of a narrative of four complete states of being.

Distinct in terms of their medium these extraordinary textiles are also unique in their literary and musical ideas. They may be seen as the climax of Traquair's quest for a 'book of life' in which narrative and allegory were fully synthesised. Long engrossed by the Renaissance studies of Walter Pater, she decided this time to work directly with one of his texts. 'Denys l'Auxerrois' was the second of four tales recently published as *Imaginary Portraits* (1887). A story in which the narrator uncovers the imagery in a set of tapestries, it had obvious appeal for Traquair the textile artist, who responded to it by working out her own imagery. Her four panels are, therefore, not direct illustrations of the text; rather, they contain reflections on its key concepts.

It is not difficult to see why Traquair was attracted to this text. In 'Denys l'Auxerrois' Pater weaves a cultural equilibrium, specifically bonding the secular and the religious in the central

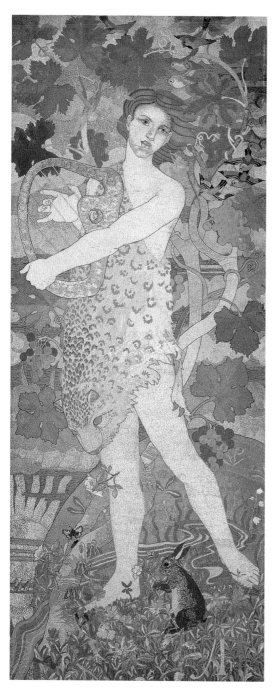
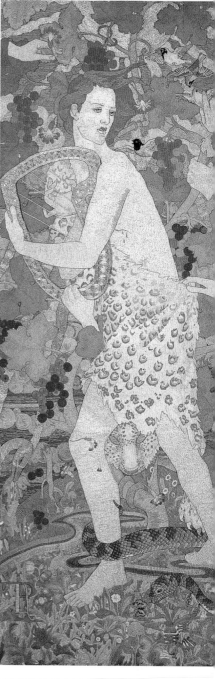

[39] *The Progress of a Soul* **1893–1901**

Silks, gold and silver thread on linen, left to right:

The Entrance **1893–5** 180.7 x 71.2 cm

The Stress **1895–7** 180.7 x 71.2 cm

Despair **1897–9** 184.7 x 74.9 cm

The Victory **1899–1902** 188.2 x 74.2 cm

As told by Walter Pater in his *Imaginary Portraits*, the narrative tale of Dionysius or Denys was inspirational to Traquair. Using embroidery as a craft capable of integrating a range of ideas, she produced magnificent textiles which were to hang in the stairwell of her home. In her creative use of traditional stitches, Traquair modernised embroidery.

Scottish National Gallery, Edinburgh

INNOCENCE AND EXPERIENCE

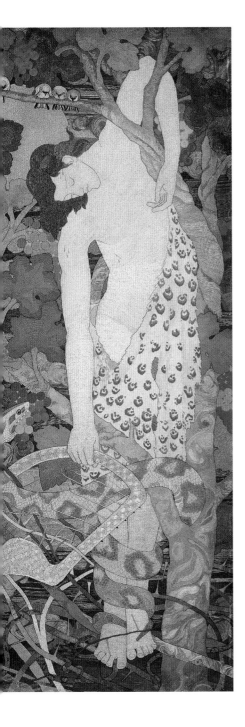

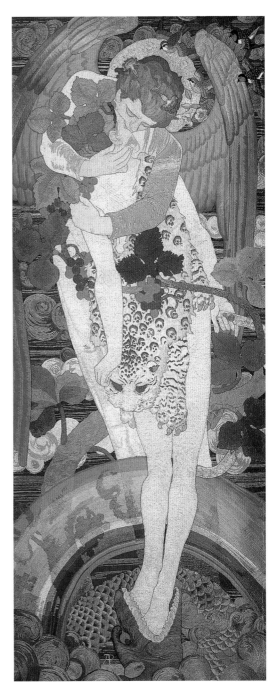

figure of Denys. The builder of the new cathedral organ in Auxerre, he is a realisation of the humanistic ideal, a man who through his presence and actions reinvigorates the community. Initially the pagan Dionysus, he later assumes the reflective character and appearance of Denys the monk. The tale ends with Denys playing the central part of Winter in a pageant, hunted blindfold and torn apart by his own people. It is both a simple linear narrative and an allegory of the cyclical nature of culture and human behaviour. Through the text medieval and Renaissance imagery are interwoven as metaphors of discord and harmony.

In his story of Denys, Pater plays with ideas of reoccurrence and time, concepts then fashionable in the cultures of Britain and France (where, of course, the story is set) from literature through art and architecture to music. Of the arts time is most central to music, and Pater refers to wind music, church instruments and the sound and rhythm of nature. Denys 'like the Wine-god of old … had been a lover and patron especially of the music of the pipe, in all its varieties' and the organ installed in Auxerre was 'famous for its liturgical music'. He refers to the 'homely note of the pipe, like the piping of the wind itself from off the distant fields'. For Denys, the building of the Auxerre organ 'became like the book of his life: it expanded to the full compass of his nature, in its sorrow and delight'. Apollo, the adversary of Dionysus, makes a brief appearance in Pater's narrative as a disapproving iconic decoration of the new organ.

The tale and its potential clearly entranced Traquair. Here was a story which shifted from 'sorrow' to 'delight', in which a pagan narrative evolved into one of Christian values. As well as bonding art to literature, she would also integrate her own experience of music, so vital to Pater's 'imaginary portrait'. In 1894, less than a year into her first panel, she visited Bayreuth in the company of the Whytes. For her, Wagner, a composer who had abolished boundaries between the performing arts, was now 'of the Dante class, not the Shakespeare'. They attended *Parsifal* and two performances of *Lohengrin*. For Traquair *Parsifal* was a

> *true drama of a soul's development, impossible to divide*
> *the music from the idea, it is a thing for all time, for each*
> *individual soul passes through much the same experiences,*
> *modified it may be by circumstances … the unconscious*
> *living, the awakening, knowledge of good and evil, despair,*
> *escape from self perception of beauty, forgiveness of evil,*

[40] *The Entrance* (detail)

This detail of a rabbit shows the imaginative way Traquair used colour and stitches in adjacent sections of her design. Each such 'simple' detail has also a symbolic meaning.

birth of the new life, there one traces each step through much pain, and wanderings, till all is lost for ever in a glorious harmony.

Traquair stitched such music into the linen, little by little, carrying its key ideas in her mind's eye. At any one time she only viewed at most a third of each panel on her frame. They form a passionate account of the trials and triumphs of life, from innocence to death and transfiguration, a fabrication of 'glorious harmony'. Like Pater's 'flaxen and flowery creature, sometimes wellnigh naked among the vine-leaves', her Denys, an 'oft-repeated figure', dominates the designs. He also has 'all the regular beauty of a pagan god'. Traquair, like Pater, sought to integrate a range of opposing cultures, but in her case most notably the Celtic with the classical, the sacred and the profane. She enjoyed working with the dynamics of difference, but could also identify common values, regarding 'all art from prehistoric times down to the 16th century as decorative' with 'as a rule decoration subordinate to narrative'. Like John Duncan in his Ramsay Garden murals, she identified classical elements within Celtic culture.

In her first panel, *The Entrance* (1893–5), Denys (still effectively the pagan Dionysus) is almost an Apollonian figure but, like a Celtic bard, he sings and plays a golden harp. In this image, the sun rises, the figure walks in harmony with nature. A rabbit, a detail taken from *Taste*, one of the fifteenth-century Unicorn tapestries in the Musée de Cluny in Paris, dominates the central lower foreground [40]. The rabbit is a traditional symbol of lust: the panel is concerned with the pleasures of youth as much as innocence.

As Denys advances through time and life, so he ages and shadows pass across him. In the second panel, *The Stress* (1895–7), nature is now 'red in tooth and claw' as the rabbit hangs dead from the beak of a large bird while hands reach out to catch smaller, flying birds and remove Denys's leopard skin. A reptile wraps itself round his legs to impede his progress. The gradual emergence and integration of Christian with pantheistic symbolism is as subtly interwoven as that of Celtic and classical cultures. Traquair, more deliberately than Pater, transforms her Apollonian-Dionysiac character into a figure not only Christian but bearing the very attributes of Christ himself. In this second embroidery Denys's torso bleeds, a reference to Christ's Crucifixion or the theme of doubting Thomas which she was also currently illustrating in the south chapel of the Catholic Apostolic

[41] Edward Burne-Jones,
The Briar Wood 1874–84 (detail)

One of four canvases painted for industrialist William Graham, but sold to Agnew's in 1885, was exhibited there to critical and popular acclaim in 1890, and finally purchased by financier Alexander Henderson (later Lord Faringdon) for the Saloon at Buscot Park, Oxfordshire. In the work *Despair*, Traquair responded to both the overgrown briar and the individual poses of the sleeping knights.

The Faringdon Collection Trust, Buscot Park, Oxfordshire

Opposite [42] *Despair* (detail)

In the lower section of *Despair*, Traquair worked a powerful three-dimensional image of wild, destructive nature. The panel illustrates the energy and power of the natural world.

Church in 1896. There it is part of a sequence of images which together state that divine life may not be imparted, but rather achieved by each individual soul: here such a concept is encapsulated in the person of Denys.

The third panel, *Despair* (1897–9), introduces further Christian symbolism into an essentially pagan scene as an exhausted Deny hangs on the branches of the vine. At the foot of the panel a briar chokes nature. As Traquair adapted Pater, so she also absorbed ideas from the work of Edward Burne-Jones. In May 1890 she had admired his *Briar Rose* series of paintings at Agnew's – 'splendid such colour and a splendid feeling for line' [41]. The memory of h work stayed with her, images of the sleeping court and rampant briar – a metaphor of time – to be adapted seven years on. Burne Jones's Sleeping Beauty is matched by Traquair's Denys. But while Sleeping Beauty is merely asleep, Denys, exhausted throug life's experience, is on the point of death. In an allusion to Christ Crucifixion, he hangs on the tree, briar thorns poised to pierce his feet [42]. The harp is now broken. Birds on a branch bow their heads in a sympathy of nature [43]. The darkness of mood is reflected in the range of subtle tones and colour.

The fourth and final scene resolves Traquair's narrative. It is as dramatic as it is rich and beautiful. Like the princess who 'lived happily ever after', Denys is awoken on death to eternal life with a kiss. *The Victory* (1899–1902) is a scene of 'death and transfiguration', with as much texture and colour in it as Strauss' 1889 tone poem of that title. As a soul leaving the body, so Denys soars passively into the arms of a red-winged, red-haired seraph; here Traquair also responds to the sweet peace of Cardinal Newman's fashionable narrative poem, *The Dream of Gerontius* of 1865. Turning initially to William Blake [44], Traquair again synthesised her ideas in a reference to the jaws of hell, represented here, as in early medieval manuscripts, by the gaping mouth of th reptile who had entered the sequence two panels earlier. The monster stands for the presence of adversity in life. Denys's fingers tense in semi-erotic pleasure as he receives the gift of everlasting life and enters the realm, or state, of heaven. The stream, a river o life, from the other panels is now replaced by a glorious rainbow passing between angel and mortal. The power of the image, range of colour and imaginative stitchery are all remarkable.

Traquair used luxury materials in a vibrant intensity of surface – her stitches are animated, gold thread used in spirals to catch the light to give a particularly rich texture [45]. Many

INNOCENCE AND EXPERIENCE

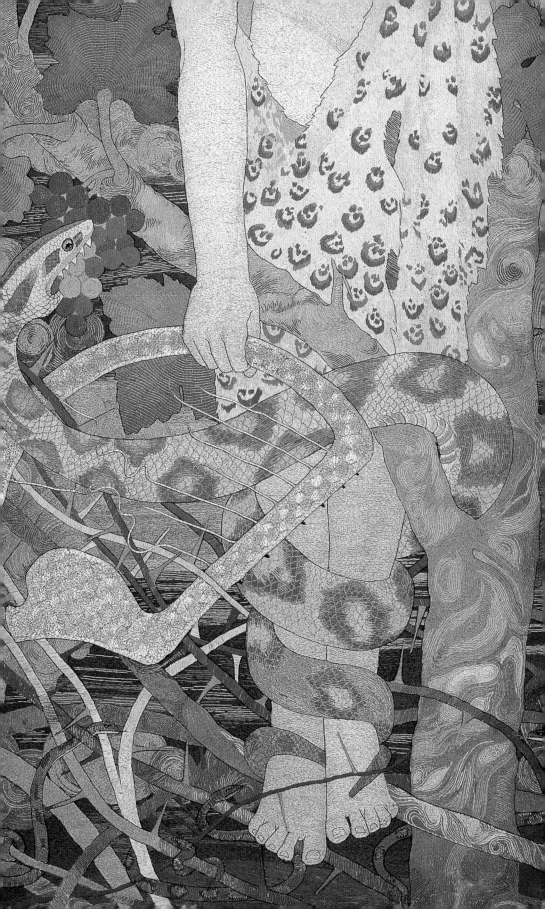

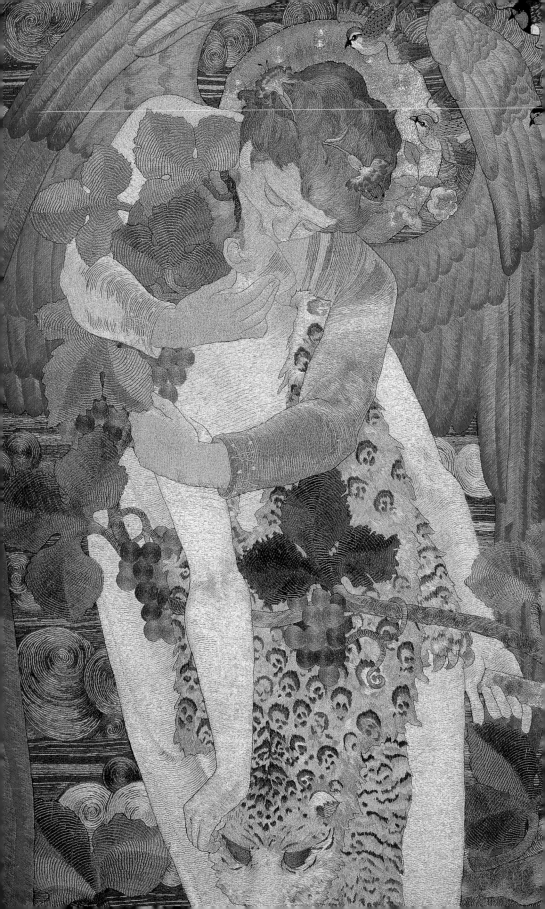

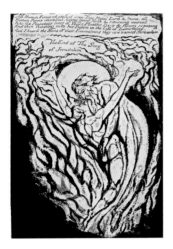

[44] William Blake, *The Union of the Soul with God* Plate 99 from *Jerusalem: The Emanation of the Giant Albion* 1820

Blake's image of the soul reunited with God is the climax to his late poem, *Jerusalem*. In Traquair's *The Victory* her red-winged angel replaces Blake's patriarchal figure of God. In 1959 the art historian Anthony Blunt wrote of Blake's image that 'here the artist has expressed the final state to which man can aspire by means of love and imagination after passing through the dark stage of Experience', words which could equally be applied to *The Victory*.

British Museum, London

Opposite [45] *The Victory* (detail)

Below [43] *Despair* (detail)

Birds, the musicians of nature, have been silenced in *Despair*, but sing once more in the last embroidery, *The Victory*.

stitches used are traditional, even medieval, ones. Satin stitch, split stitch and long and short stitch are common in all her work: laid and couched work which she had employed from the 1880s had been a feature of the Bayeux Tapestry. Stem stitch was used magnificently for flesh areas, worked in such a way to give an illusion of three dimensions. It delights the eye, the hand, the mind.

The art historian Bernard Berenson famously wrote in 1894 in *Painters of the Italian Renaissance* that 'the stimulation of our tactile imagination awakens our consciousness of the importance of the tactile sense in our physical and central functioning, and thus, again, by making us feel better provided for life than we were aware of being, gives us a heightened sense of capacity.' No other Arts and Crafts textiles brought together so acutely that meeting of the real and the psychic which Berenson identified in Florentine art. Yet although in its richness *The Progress of a Soul* may be the visual antithesis of the spare economy of work by Traquair's Glasgow contemporary Jessie Newbery, both women aimed to heighten intellectual and physical awareness in equal measure.

For Traquair music also had the power to produce this 'heightened sense of capacity'. Wagner, like Pater, was admired by her not only for his lack of clear distinctions between art, myth and reality but between generic art forms. She valued the multilayered allegory of life achieved by both men, and worked their ideas into both her mural work at Catholic Apostolic Church and her embroideries. *The Progress of a Soul* on one level is a work of intense beauty and creative craft skill. On another, and like the story of Denys it portrays, it presents the pains and triumphs of all human experience. Ambitious and successful, *The Progress of a Soul* is a key work of the period.

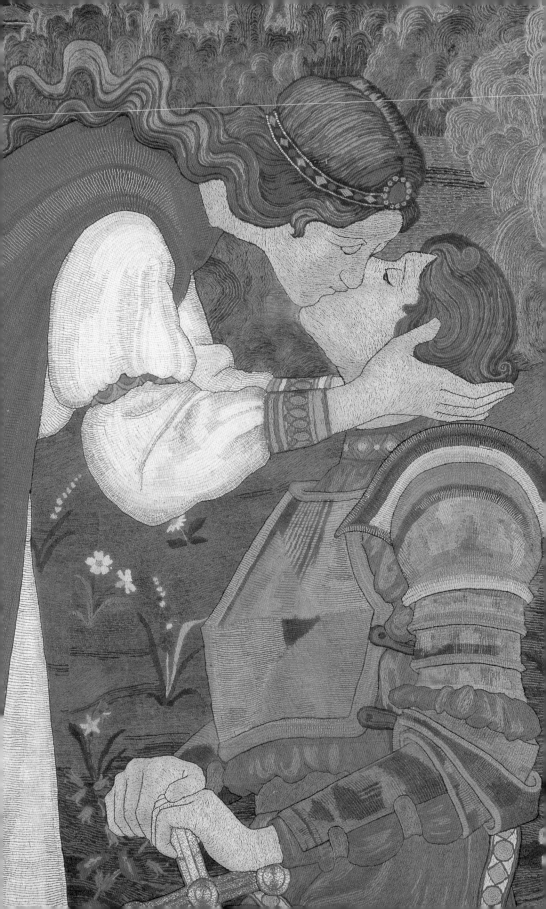

4 Arts and Crafts

In 1900 William Hole (1846–1917), the Edinburgh artist and printmaker who had recently decorated the entrance hall of the Scottish National Portrait Gallery, proposed Traquair for election to the Royal Scottish Academy. Despite her established status in the arts and contributions to annual exhibitions through the 1890s, she was turned down on the grounds that 'Mrs Traquair is not an artist by profession within the meaning and intention of the Charter'. This snub seems to have had little impact. Confident and assured, by the turn of the century she was stepping up her involvement with the British Arts and Crafts community. Participation in group exhibitions was to be increasingly important as various crafts jostled for position within her working day. Towards the end of the decade she moved further into creative partnerships, and worked most closely with Robert Lorimer.

As noted, her entry to the world of public Arts and Crafts exhibitions had been modest but international – a binding of *In Memoriam* was sent to Chicago in 1893. Two years later she sent single embroideries plus *The Salvation of Mankind* [**12**], her embroidered panels of 1886–93, and illuminated pages of *Sonnets from the Portuguese* to Francis Newbery's large Arts and Crafts exhibition in Glasgow in aid of the Soldiers' Home in Maryhill. Her *Salvation* was also shown in 1895 in Dublin with the Arts and Crafts Society of Ireland where a critic commented on its 'broadness of treatment, decorative feeling, colour and dexterity in dealing with a difficult subject'. It was also deemed by *The Studio* 'comparable though not of course quite equal' to Burne-Jones's recent designs for the Morris company, marking her first, but far from last, mention in that journal. In the 1900s Traquair was to be regularly written up.

Her embossed leather book covers had been shown in Edinburgh and also from 1898 with the Guild of Women Binders in London and at the 1900 Paris Exposition Universelle. In 1899 she showed for the first time at the Arts and Crafts Exhibition Society in London, contributing unbound illuminated pages, possibly from *The House of Life* [**27**] or duplicate pages of her Barbour manuscript [**26**] or *Sonnets from the Portuguese* [**25**]. Lorimer

The Red Cross Knight
Detail showing *The Red Cross Knight and his Lady* 1907–14

had shown with 'the Arts and Crafts' since the fourth show in 1893 and by 1899 was a member of the society. Traquair was a member (although not of its parent society, the Art Workers' Guild) from 1903 and remained an exhibitor until 1910.

To show in London with the Arts and Crafts was a mark of Britishness and professional standing. Work was selected by some of the country's leading designers, architects and craftsmen. Traquair, who paid regular visits to the capital through the 1890s, would have been struck by the range and proficiency of exhibits. To pursue a craft career she would have to send work to the exhibitions which were mounted every three or four years. Seeing the exhibitions and reading detailed reviews in *The Studio* must have played a not insignificant role in launching her into a new area of craft – enamelling. Two people would also persuade her to take it up. Sir Henry Hardinge Cunynghame, for whom she had illuminated *In Memoriam* and a second copy of *The Dream*, was an amateur enameller and also wrote two books on the subject. In one, *European Enamels* (1906), he referred to Traquair – by now at the heart of British enamelling – as having studied the medium with Lady Gibson Carmichael (1863–1947).

Like Cunynghame, Mary Carmichael had studied the craft with Alexander Fisher (1864–1936), London's leading practitioner and teacher in the area. In 1899 Traquair had started her illumination of *La Vita Nuova* for Sir Thomas Gibson Carmichael and, early in the following year, was invited to spend time at Castlecraig, his Peebleshire home [29]. There she enjoyed a library ranging from Caxton to Andrew Lang and a house furnished with, as she wrote, 'the very best of Italian art in pictures, missals, marbles, iron and church things, beds hung with Florentine embroideries (for one to sleep in)'. She enjoyed having 'kind, rich friends, as if I was really rich and had nice things it would damp my working energy'.

Both the company and the collections at Castlecraig were deeply pleasurable. Sir Thomas was no mere dilettante but one of Britain's leading collectors. A man of letters, he served as Liberal Member of Parliament for Midlothian in succession to William Ewart Gladstone, and later as Governor of Victoria, Madras and Bengal. For his cultural knowledge, especially of Italian art, he would also serve as a trustee of a number of major collections including the Scottish National Gallery, and in London, the National Gallery, the Wallace Collection and the National Portrait Gallery. He knew Berenson and was highly regarded by

[46] *Angels with Trumpets c.*1903
Tempera, oil, gesso and gold leaf on panel
84.9 x 83.5 cm

Curiously, this Italianate painting on
wood seems to have been painted for
the courtyard exterior of the London
residence of Sir Thomas and Lady Gibson
Carmichael. A deep wooden baton
applied across the upper edge provided a
limited amount of surface protection.

Private collection

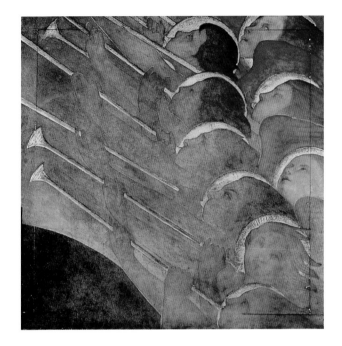

the art historian Tancred Borenius. Yet the Carmichael collec-
tions, to be dispersed through sales in the 1900s, are today little
known. They encompassed a range of work from Byzantine
ivories to French metalwork, bronzes of the fourteenth to
seventeenth centuries, antique glass, Chinese and European
porcelain, terracottas, furniture and tapestries. In addition, his
fine collection of Indian art would be lost en route for Britain
when the *Medina* was torpedoed off Devon in 1917.

Staying at Castlecraig allowed Traquair to discuss both
British – Sir Thomas sharing her keen interest in Blake – and
European culture, in particular that of Italy. On a visit to that
country he had brought back a 1590s carved ceiling to be in-
stalled in the small drawing room at Castlecraig. This was
removed in 1908 to the modest Arts and Crafts house designed
for him in the village of Skirling, near Biggar, by Traquair's son
Ramsay (1874–1952). A 1903 sale of books from his library
recorded no fewer than seventy-five Dante items: all had been
made available to her while illuminating *La Vita Nuova*. The
friendship between connoisseur and artist resulted in two further
commissions, both for the courtyard of the Carmichaels' London
residence at 13 Portman Street: a square painted panel [**46**] of
angels blowing gilded trumpets (inspired by Mantegna's paint-
ing *The Triumphs of Caesar* in the Royal Collection, previously
adapted for both the Song School east wall and the Barbour

cabinet) and, much later, a wrought iron figure of St Michael (made by Thomas Hadden (1871–1940) about 1919: now resited in Warfield near Bracknell).

However, there were many other attractions at Castlecraig, not least early Italian, German and French enamels which already had encouraged Mary Carmichael to study the craft. Enamelling was a challenge and indeed a thrilling chemical experiment. Percy Nobbs (1875–1964), an architect friend of Traquair's son Ramsay, was by now a regular correspondent on art matters. Both young men had fenced for Britain in the 1900 Paris Olympics. Traquair wrote to him from Castlecraig of happy mornings spent in the small enamelling workshop:

> … and since then I have been writing down notes and names to profit by when I return to Edinburgh. Not that I shall ever do decent work but I may be able to do some-thing good enough to use as secondary matter, to say nothing of the pleasure I get pottering amongst ground glass, mortars, acids, etc.

Initially she worked closely with the historic enamels, basing her work on a Limoges Crucifixion. Traquair and Carmichael also collaborated on at least two enamelled crosses, one of which was shown at the Edinburgh Arts and Crafts Club (founded in 1897) and the Royal Scottish Academy in 1902, an exhibition where London Arts and Crafts enamellers such as Henry Wilson and Nelson and Edith Dawson were represented. By that date Traquair had begun to produce enamels to her own individual iconography [47]. Now experienced at handling minerals and firing temperatures, she was attempting a wide range of work.

Alexander Fisher's work had been well published by the early 1900s. In 1896, in an interview in *The Studio*, he had advocated the triptych form as 'the most sacred of all subjects'. In 1906, with the medium's established popularity for jewellery, he would emphasise the sensuous, romantic qualities of the painted enamel which could convey

> all the bewildering surfaces, all the depths and lovelinesses that lie darkly in the waters of sea-caves, all the glistening lustre of gleaming gold or silverback and fin of fish, the velvet of the purple sea anemone, the jewelled brilliance of sunshine on snow … the flame of sunset, the very embodiments in colour of the intensity of beauty.

These were values to which Traquair ascribed. She wrote to Percy that she wished to capture the beauty of an Edinburgh

[47] *Sanctuary* 1902

Enamel on copper, set as a pendant in silver
with three enamel drops and a silver chain
set with seed pearls 5.2 x 5.3 cm

This was Traquair's first enamelwork
commission, from Robert Lorimer as a
present to his fiancée Violet Wyld. Already
the image of the angel helper, to be so
popular in her jewellery, was fully
established. This piece was one of
twenty-two Traquair enamels exhibited
at the 1903 Arts and Crafts exhibition in
London. When Lorimer married that year,
Traquair provided enamel jewellery as
presents for the bridesmaids.

Aberdeen Art Gallery and Museums
Collections

September sunset using a palette from amber to deep blue. Her
enamelling continued to mix spiritual and secular subjects. She
would produce more than three hundred pieces of enamelwork in
twenty years. Half were set as jewellery and half as display
enamels mounted in boxes, caskets and triptychs, framed on
simple or elaborate medievalised settings [**48, 49, 53**].

As Traquair's confidence and skill grew, she produced jewel-
lery specifically for major Arts and Crafts exhibitions, offering
pendants at an average price of eight to ten guineas and triptychs
for thirty guineas. Her enamels were narrative, often making
reference to one of her paintings, bindings or illuminations or
telling a new story. Traquair's journey of the spirit, her 'drama of
the soul', now widened to embrace tales from classical literature
alongside Spenser, Pater, Rossetti or the New Testament. A
popular narrative was Apuleius's story of Cupid and Psyche,
worked time and time again as pendant or display enamels
between 1902 and 1918 [**50, 51, 52**]. In the field of the decora-
tive arts it had been particularly used in Italian and French glass
and ceramics. The subject had been illustrated by Burne-Jones for
Morris's *The Earthly Paradise* in 1865 and by Crane in 1872–81
in a frieze for George Howard, Lord Carlisle. Fisher had famously
used it for a casket in 1900. Traquair recognised the popular

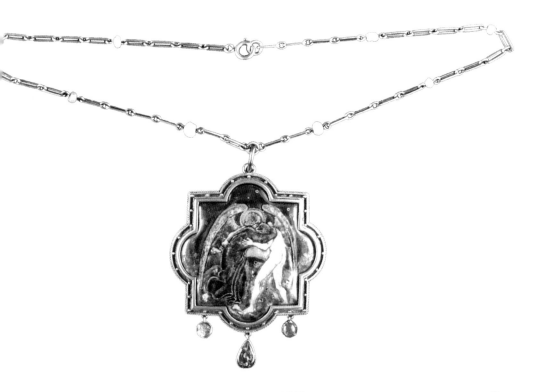

[48] *The Denys Casket c.1906*

Wood-lined copper-gilt casket set with twelve enamelled copper plaques and a fixed bar terminating in two moonstones

19.5 x 16.4 x 8 cm

The closeness of Traquair to her brother, William, resulted not only in fine illuminated manuscripts but also this casket, a more literal working (although still interpretative) of Pater's story of 'Denys l'Auxerrois' than the earlier embroideries, *The Progress of a Soul,* made for herself. The style of imagery is animated and decorative. Her written account of the casket narrative has been kept with it.

Estate of the late Sir Paul Getty KBE, Wormsley Library

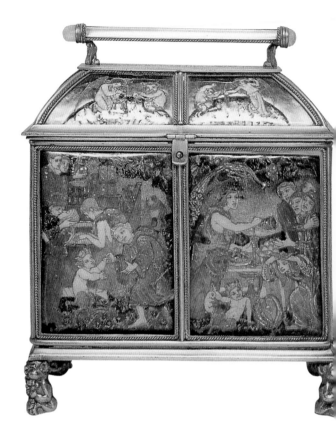

Opposite **[49]** *The Ten Virgins Casket c.1907*

Wood-lined silver-gilt casket set with twelve enamelled copper plaques and decorated with semi-precious stones

23.5 x 31.7 x 16.5 cm

The two grand caskets designed by Traquair to support enamels belong to the mid-1900s when she was fully participating in British Arts and Crafts exhibitions. Both are essentially narrative, one based on Pater and the other on a New Testament parable. Traquair used *chasse* form to equate her modern work with medieval precedent. This casket was probably made by Brook and Son of George Street, Edinburgh, in a hand-built style which curiously incorporated lettering from the parable text in reverse with some letters also mirrored. Her skill in shaping and enamelling the copper plaques for the sides and particularly the lids both here and in the Denys Casket [48] is significant.

Hunterian Art Gallery, University of Glasgow

appeal of the subject and worked on many variations of Cupid ('a strong youth, drawing a big bow') including *Cupid the Earth Upholder* and *My Lady Crowns Love* [**50**]. She viewed the story as a classic of the spiritual journey. As she worked on an early enamel of Cupid in March 1902 she wrote to Percy, 'I love the story, it is just life, the life of creation in our sense of the individual … are we not each a little universe and each goes through all the stages?'

By 1903 Traquair had already established her standard method of working and colour range. With a few exceptions, most enamelling was applied to copper plaques, cut to the required shape and modelled in repoussé with the figural design. Occasionally she worked on silver or gold. She began to mix fragments of metal foil with the liquid, unfired flux to provide texture to catch the light. In most enamels a green ground is studded with red flowers edged in gold, with figures presented in deliciously pearly flesh tones. Angels, who often comfort mortals (dressed in green, or sometimes red or blue), nearly all have red wings.

ARTS AND CRAFTS

As had been the case with some, but not all, of her illuminated pages, Traquair was now making detailed preparatory studies, partly in order to show a client, even if he were her own brother. She also designed the settings of her jewel enamels. For the latter she would produce a pencil sketch and all the required components to be used by the jeweller – enamel drops or seed pearls for an ordinary or Celtic chain, natural pearls for Renaissance drops, individual enamel side plaques for a necklace. One jeweller she frequently used was J. M. Talbot, but she also turned to the commercial firms of Brook & Son of George Street and Hamilton and Inches of Princes Street. She would request friends and family to look out for suitable gold chains.

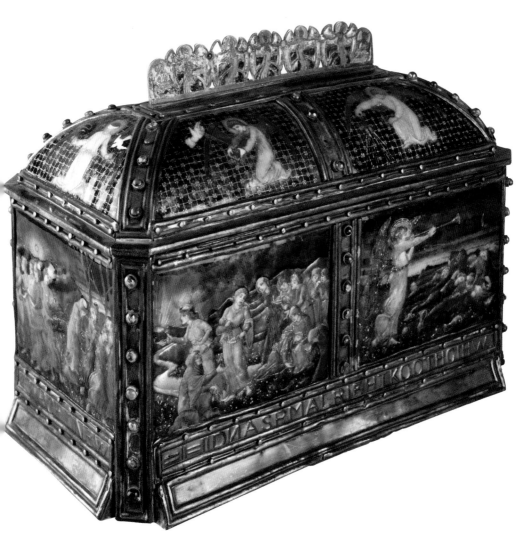

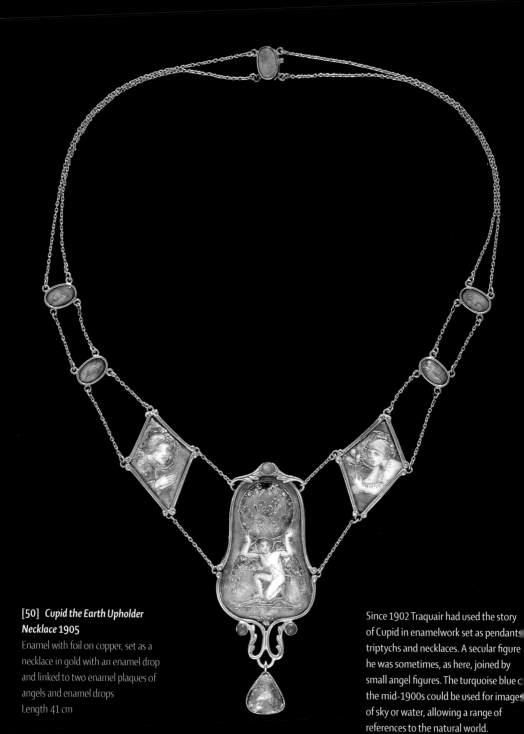

[50] *Cupid the Earth Upholder Necklace* 1905

Enamel with foil on copper, set as a necklace in gold with an enamel drop and linked to two enamel plaques of angels and enamel drops

Length 41 cm

Since 1902 Traquair had used the story of Cupid in enamelwork set as pendants, triptychs and necklaces. A secular figure he was sometimes, as here, joined by small angel figures. The turquoise blue of the mid-1900s could be used for images of sky or water, allowing a range of references to the natural world.

National Museums Scotland, Edinburgh

[51] *Psyche Chalice* 1906

Paua shell mounted in silver by J.M. Talbot

Height 34.1 cm

One of several settings designed in German Renaissance style by Traquair's son Ramsay in 1905–6, this silver-mounted piece is decorated at both the rim and stem with enamelled copper plaques illustrating scenes from the story of Cupid and Psyche. The enamel colours were calculated to partner those of the shell, thus uniting nature and craft.

National Museums Scotland, Edinburgh

Other materials were sought. Wood was used for simple caskets or small circular frames. Traquair's two Madonna caskets, her response to medieval or Byzantine ivories, were made of rosewood and set with rose enamels. But for more elaborate objets d'art to match historic work she needed a designer with whom to work. Thus from late 1905 she involved her son Ramsay in the design of settings for her display enamels. These were to be made up by jewellers in copper, silver or modern electroplate. Brook and Talbot were her favoured makers for the majority of such pieces. Ramsay Traquair's triptych forms were inspired by German work, while, following her younger son Harry's marriage to New Zealander Beatrix Nairn, paua shells were cradled in silver mounts for which Traquair made enamel decorations. The colours of these were intended to partner the natural beauty of the shells [**51**].

With enamelling now one of her principal crafts, Traquair took advantage of the British exhibition circuit. In Scotland, in addition to the Royal Scottish Academy and the largely amateur Edinburgh Arts and Crafts Club, she exhibited, although less frequently, with the Scottish Guild of Handicraft and the Society of Art Workers in Glasgow and the Aberdeen Artists' Society. Networking locally, she also designed costumes for the *Scottish National Pageant of Allegory, Myth and History* held in the grounds of the Scottish National Exhibition in June 1908. Her designs for the Early Church section partnered those of John Duncan for the Celtic Group, Jessie M. King (1875–1949) for an Arthurian Group and De Courcy Lewthwaite Dewar (1878–1959) for a Symbolic Group. All were reused in a Glasgow University charity pageant that October.

Through the 1900s Traquair's principal focus and ambition was nevertheless fixed firmly on London. In March 1902 she wrote to Percy that she 'wanted to have something nice' for the Arts and Crafts Exhibition Society the following year. In the same letter she was clearly anticipating the completion and exhibition of *The Progress of a Soul*: 'I doubt if it would be an advantage if wishes were actions. What a chaos we would soon make and then there would be nothing left to struggle and strive for, nothing to give the joy of triumph, or pain of despair.' She sent not only unbound pages from *The House of Life*, but some twenty enamelled triptychs and pendants, and *The Progress of a Soul*, the latter never exhibited in Scotland in her lifetime.

During the 1903 exhibition she reflected on art and on her

embroideries, priced by her at £1,000 to reduce the chance of a sale; these were precious textiles into which she had stitched so much of her personal ideas and beliefs. She wrote of the

> *wonderful beauty of words which just exactly reflect the speaker or writer's thought … or in line or colour, just the exact line to convey the feeling meant or the tone of colour which gives just the throb desired. So the whole passes into music … often I have imagined a human life like that. Every action and manner of being forming a whole which exactly reflects the individual soul.*

With their perhaps overcomplex iconography, London critics were cautious in their praise of the textiles, referring to them as simply 'the most ambitious embroideries shown'. Through the early 1900s Traquair also worked through a range of embroidery designs, not all of which were actually made up. Some reused ideas from her manuscripts, such as *The House of Life*; others

[52] *Necklace* 1917–8

Enamel on copper, set in gold and mounted on a gold chain set with enamel

This late necklace reused five images from earlier enamels, from Mary teaching Christ to walk, a Pietà and a Coronation of the Virgin to Cupid the Earth upholder and Cupid with his 'big strong bow'. To complement this eclectic mix, Traquair designed a chain with alternating floral and Celtic links.

National Museums Scotland, Edinburgh

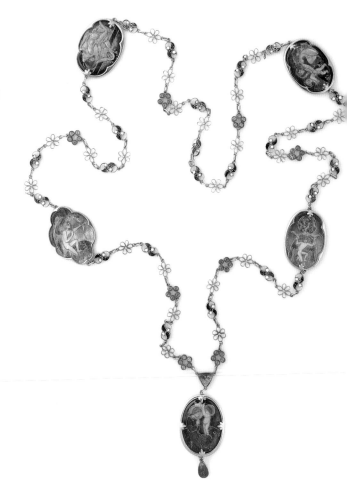

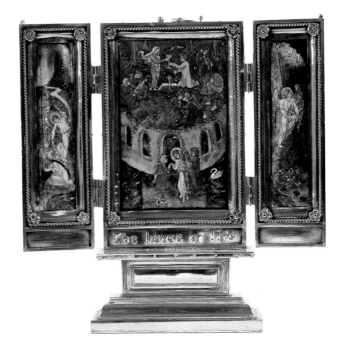

[53] *The House of Life* 1903

Enamel with foil on silver, set in a silver frame and stand made by J.M. Talbot

Height 18.8 cm

Traquair treasured this particular triptych which was exhibited at the 1906 Arts and Crafts exhibition in London. She gave it to the Royal Scottish Academy on her honorary election in 1920. It reworked key images from her recent illumination of the sonnet sequence by Rossetti. Both show awareness of western and eastern manuscripts in the depiction of an earthly paradise.

Royal Scottish Academy, Edinburgh

were inspired by medieval designs, the signs of the zodiac or the seasons. Enamels displayed in exhibitions led to commissions for duplicates or other pieces, and, in addition, the summers of 1904 and 1905 were taken up with a further mural decoration, this time in England, for the chancel of a fifteenth-century church in the Nottinghamshire village of Clayworth. Commissioned by Lady d'Arcy Godolphin Osborne as a thank-offering for the safe return of her son from the Boer War and a commemoration of a second son, the decoration provided an angel choir to accompany an Adoration of the Magi [**54**]. Traquair also provided an Annunciation and scenes of the Entombment, the Resurrection

[54] North wall, chancel of St Peter's Church, Clayworth, Nottinghamshire 1904–5 (detail)

The decoration of the chancel of St Peter's Church included an angel choir for which local children posed. In the foreground are Jack Marsh (aged ten, dressed in red) who firmly holds the head of his restless young cousin Anthony Otter (aged eight, in yellow). Otter, who would become Bishop of Grantham, later recalled posing for Traquair in the red brick farmhouse by the canal bridge at Clayworth. His sister Mary Otter, aged twenty-two, is pictured to the right in the row above.

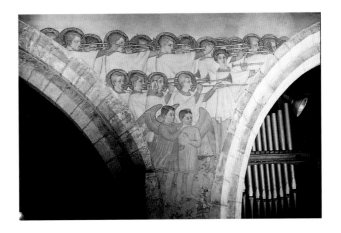

[55] *The Red Cross Knight*

Silks and gold thread on linen

Each panel 191.7 x 82.3 cm, left to right:

The Red Cross Knight and his Lady
1907–14
The Red Cross Knight 1904
The Red Cross Knight and his Lady Riding
1904–7

Working three large panels between 1904 and 1914 became an increasing challenge. Traquair worked the central section in a matter of months, much faster than earlier embroideries or the two wing sections. The complete design was in fact to be first realised as an enamel triptych in 1905 and again in 1906. However, much of the elegance of the central embroidered panel was lost in translation to enamel. This panel in both handling of luxury materials and elegance of design reflects her appreciation of sixteenth-century north Italian painting, particularly the Ferrara School. The second and third panels (worked jointly by Traquair and her daughter) differ in tone and vibrancy from the first central section.

National Museums Scotland, Edinburgh

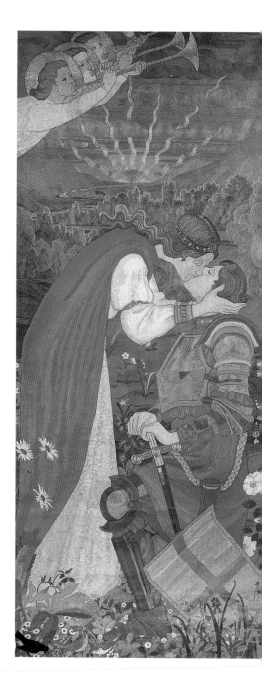

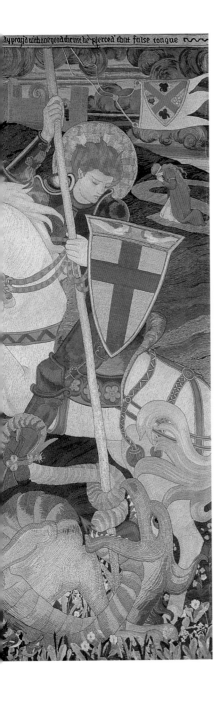

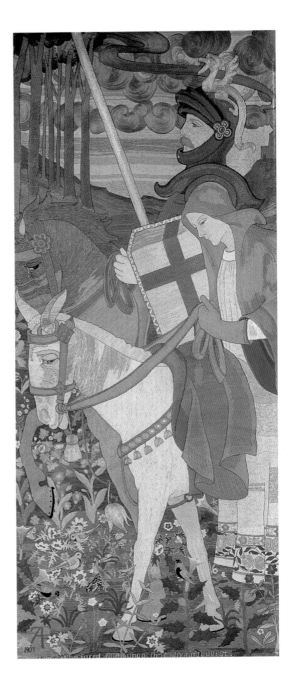

and Ascension, Christ in the Garden of Gethsemane and the Institution of the Last Supper, wrapped in a deep border. As at the Song School portraits of local families were included.

On Dr Traquair's retirement from the museum in 1906, the couple moved to The Bush, a house in Spylaw Bank Road in the village of Colinton to the south-west of Edinburgh. Here Traquair rejoiced in a new enamelling kiln, a south-facing garden and views beyond to the Pentland Hills. Traquair took to gardening, lifting and dividing her plants for colour, and even budded roses. She would greet visitors in 'housemaid's gloves, big boots and a gardening overall'. The care and attention she gave in equal measure to nature and craft paid off. At the eighth Arts and Crafts that year critics enthused over her enamelwork, *The Studio* critic commenting that 'enamelling is Mrs Traquair's medium we do no doubt'. A triptych of *The Red Cross Knight* was considered 'a pleasant and effective, even noble decoration'. Moreover, it was 'notable as a design in colour ... the qualities which are attained in enamel by a worker with a sensitivity to colour make it peculiarly a medium which satisfies an artistic nature.'

In the display enamels of the 1900s, serial imagery, such a core element within Traquair's mature 1890s work, was still a defining factor. However, symbolism was giving way to more purely decorative values. *The Kiss*, a triptych made in 1903 and shown in Dublin the following year, marked a change to the illustrative. Doubtless, this was motivated by the collective character of Arts and Crafts exhibits and client taste. The *Denys Casket*, a copper gilt casket of late 1905 or early 1906 made for William Moss, provided a more literal reading of Pater's tale, infused with elements from 'Apollo in Picardy' from his *Miscellaneous Studies* (1895) [**48**]. Traquair had read *Miscellaneous Studies* soon after publication and nicknamed her son Harry 'Amis'. For William she also made *The Ten Virgins Casket* where the iconography reworked images in the south chapel of the Catholic Apostolic Church [**49**]. As with the triptychs of 1905–8, these forms, like their medieval predecessors, encourage the viewer to interact with the object, opening triptychs to reveal glorious colours and romantic images, and turning caskets to follow a narrative.

Showing her work in London advanced her visibility. *The Progress of a Soul* was re-selected by Walter Crane as part of the British display for the Louisiana Purchase Exposition the following year. By 9 January 1904 her panels had left her home for St Louis. She felt an acute sense of loss, commenting to Percy Nobbs that

my poor Denny is on his way. I'm sorry to be without him,
tho' I hope to have a new panel, St George and the Dragon,
up by spring ... it is really the Red Cross Knight, and I
think I must make an earlier design, where they set out –
Spenser has it so beautifully – then I would have a last
design.

She thus decided on a triptych format for *The Red Cross Knight*.
Illustrating *The Faerie Queene, The Red Cross Knight* again
provided a literary narrative [**55**]. As with her first triptych,
she completed the central panel first, even within the year, and
sent it to the eighth Arts and Crafts in 1906. *The Art Workers'*
Quarterly called it 'the most ambitious exhibit ... whose method
of execution was somewhat disguised'. The second panel, *The*
Red Cross Knight and his Lady Riding, was stitched more slowly,
with completion only in 1907. Less energised in its design, it
seems that Traquair lost interest in this work, now finding
embroidery a frustrating slow craft. She had enjoyed working out
the subject in enamel in 1905 and 1906. The third embroidered
panel was only finally finished in 1914, again with the assistance
of her daughter Hilda.

Enamels, illuminated manuscripts and mural decoration were
all branches of decorative painting at which Traquair excelled.
She is known to have decorated only three pieces of furniture,
and yet, in painting the last of these, the case of a Steinway
piano, she produced some of her most enjoyable work. Commis-
sioned through Lorimer by Frank Tennant in 1908 as part of the
restoration and furnishing of Lympne Castle in Kent, Traquair
would refer to this work in progress as the 'best *painting* I have
done, wood is so delightful to work on'. The piano case was sent
by sea to Edinburgh to be carved and gilded by Moxon &
Carfrae, decorated by Traquair and fitted with a Lorimer frame
carved by Scott Morton & Co. in 1909 and 1910 [**56**].

Music of various kinds was represented in this, her final piece
of serial imagery. Traquair produced beautifully detailed water-
colour studies for her nine scenes from *The Song of Solomon*
running round the case, and another for a keyboard panel to
illustrate *Willowwood*, a sonnet by Rossetti. In addition, the
inside piano lid was painted with Pan playing his pipes, with
Psyche, Eros (painted out in 1911), animals, fish and birds all
listeners [**57**]. The outside lid is decorated with a tree of life and
birds. Old-fashioned in its style, the piano was none the less well
suited to the Great Hall at Lympne. It was well received, with

[56] Grand piano for the Great Hall at Lympne Castle, Kent, 1909–11

[57] Inside lid of the grand piano for Lympne Castle, 1909–11

The piano has a stand and legs designed by Lorimer and made by Scott Morton & Co. Traquair used the case to support several independent series of paintings, from *The Song of Solomon*, a *Willowwood* panel for the keyboard, and a tree of life for the outer lid. Her scene of Pan playing to Psyche, Eros and assorted birds, flora and fauna on the inside lid was sent to Edinburgh for partial repainting with vine and putti decoration as Psyche's nude torso – in full view with the lid down – offended Mrs Tennant.

National Museums Scotland, Edinburgh

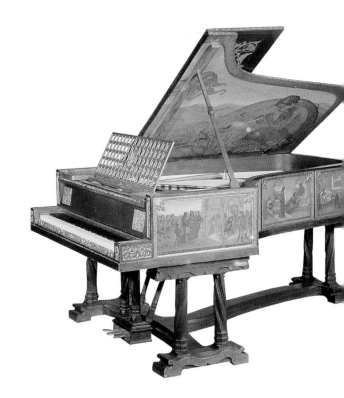

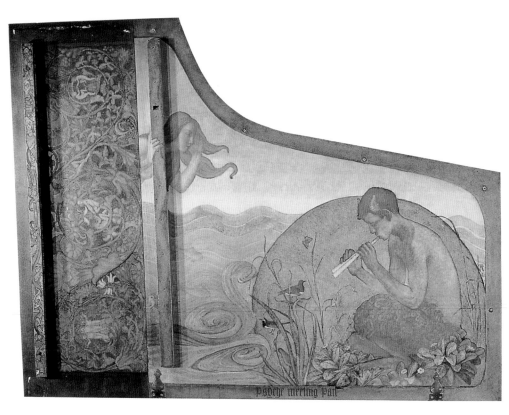

[58] *Self-portrait* **1911**

29.9 x 34.1 cm

Wearing a red velvet 'Renaissance' style cap and artist's smock, Traquair wished to represent herself as a working artist. No palette or easel is included, thus focusing attention on herself as a person. The fine brushwork and thin oil paint on panel is typical of her decorative, illustrative work at the time.

Scottish National Portrait Gallery, Edinburgh

critics making comparisons with other pieces such as Alma-Tadema's piano for Henry G. Marquand and that painted by Burne-Jones for William Graham.

Traquair's enjoyment in working with oils on wood tempted her to paint her first and only easel self-portrait. It took her two years and was eventually completed in 1911. Images of herself as scribe or book tooler had graced dedicatory addresses and the reverse of leather bookbindings in the late 1890s. She had also 'signed off' with a self-portrait at the Song School and, more visibly, in the Pentecostal scene at the Catholic Apostolic Church. Her self-awareness and confidence matured through the 1890s: to celebrate and cement her professional standing she had commissioned publicity photographs of herself in 1897 for use in exhibition catalogues and press articles [**31**]. In that year she

[59] *Study of a Girl's Head c.1907*

Oil on panel 34.5 x 26.5 cm

This beautiful small painting was exhibited in 1908 at the Royal Scottish Academy to whom it was bequeathed. The pose suggests an Annunciation, a subject recently used on the east wall of St Peter's Church, Clayworth, in Nottinghamshire, decorated in 1904 and 1905. The delicacy and realism of treatment shows a sometimes neglected aspect of her work.

Royal Scottish Academy, Edinburgh

also initiated dissemination of her work with William Hay's publication, in editions of 150, of some of her finest illuminated manuscripts – *Sonnets from the Portuguese* in 1897, her Barbour manuscript in 1898, *La Vita Nuova* in 1902 and *The House of Life* in 1904.

Her oil self-portrait [58] presents a modest, honest image of herself as artist, painted in the realist style of her (few) portraits of the 1900s [59] and adopting in the soft, thin brushstrokes used in the piano decoration. These paintings of the later 1900s have a luminosity and delicacy also found in her watercolour illustrations. The latter were reproduced in books written or edited by members of the Warrack family. Author and collector John Warrack was a friend of Lorimer and both were members of the Lamplighters' Club in Edinburgh. Traquair was closest to his sister Grace Warrack (1855–1932), author and translator, whose publications were sometimes issued to aid charities. She involved Traquair, whom she rightly called 'a lover of Italy', in supplying paintings for *Little Flowers of a Childhood* (c.1913) and *Floregio di Canti Toscani: Folk Songs of the Tuscan Hills* (1914). For her earlier *Revelations of Divine Love, recorded by Julian Anchoress at Norwich* AD *1373* (1901), Traquair had made new work which relates directly to the Morris style of illumination, but more traditional Traquair watercolours illustrated such books as *From the Isles of the West to Bethlehem* (1921) and *Une Guirlande de Poésies Diverses* (1923). The most popular of all such books was Grace's cousin Mary Warrack's anthology *Song in the Night: A Little Anthology of Love and Death* (1915) published to raise funds for wartime reconstruction work in Belgium.

From the date of her self-portrait Traquair was also working in tandem with Lorimer. There was the piano, and also a second major commission – for his new Thistle Chapel at St Giles' Cathedral. She was asked to enamel the first nineteen stallplates – one for each of the sixteen Knights of the Order plus three royal plates. She was not Lorimer's first choice: he had wished to engage Harold Soper, a friend of the Earl of Crawford and Balcarres, but was advised by Sir Herbert Maxwell to use a Scottish enameller. However, she had already felt involved as she watched Lorimer's model rise in the Dean studio, built by men mechanically copying set designs. She longed to 'get at it all to myself for one day to dash at the clay and pat life into it'.

This was work completely different from her usual enamelling. Elizabeth Kirkwood of the Edinburgh engraving firm

Alexander Kirkwood and Son was asked to prepare a sample in champlevé to be copied to readymade designs supplied by the Lyon Court. She found it 'by no means easy to do' but after a successful first piece 'could not sleep with excitement'. The chapel, a showplace for local arts and crafts, would be a 'wonderful place, pretty and containing the best carving, stone carving, marble flooring and enamel work to be got in Britain'. Traquair was paid a not insubstantial fee of £242 11s. (£242.55) for her stallplates, little different from her fee of £250 for the piano painting. Kirkwood provided all future plates with one exception, a 1928 plate for Lord Linlithgow when Traquair, now seventy-six years old, was 'amused to find I could do the work as easily as if I had never given it up'.

By the latter date she had also produced a number of late architectural commissions. The earliest of these came her way through J. Taylor Thomson of the New York office of Bertram Grosvenor Goodhue who had been articled to Lorimer and attended lectures on architectural history by her son Ramsay at the Edinburgh Art College. For the new Chapel of St Andrew endowed by the Houghteling family for the Cathedral of St James in Chicago, a triptych reredos carved by Nathaniel Grieve was set with Traquair's *The Calling of Andrew*, *Christ's Appearance to Andrew* and *The Crucifixion of Andrew* [**60**]. The complementary designs set a precedent for Lorimer's war memorials at All Saints' Church, Jordanhill (1919–20), St Mary's Cathedral (1920) and St Peter's Church (c.1920–1: destroyed in the 1960s). For these Traquair supplied familiar subjects – a Christ in majesty, with the Four Living Creatures, the three Marys at the empty tomb and, finally, a Crucifixion with Mary and St John with, again, the Four Living Creatures.

The postwar years also offered one final mural scheme commission. During the summer of 1920 she was approached by Lord Manners whose heir had been killed in action in 1914. In Detmar Blow's 1906 Italianate chapel near Thorney Hill a 1917 bronze effigy of John Neville Manners by Bertram McKennal was joined by Traquair's decoration of the apse. The chapel itself commemorated John's sister, Mary Christine, who had died in Bangalore in 1904. Their mother died in early 1920 and Traquair's mural was commissioned in her memory. Shortly after the decoration was completed in 1922, Lord Manners remarried: his bride was Zoe Nugent, the sister of Mary Carmichael. Both the Carmichaels and the Manners were committed patrons of the arts. They both,

[60] Altarpiece for the Chapel of St Andrew, Cathedral of St James, Chicago 1912

The three canvases were painted in Edinburgh and sent to Chicago with the carved and gilded frame.

for instance, commissioned sculpture from Eric Gill. Working on the chapel through the late summer and autumn of 1920, spring and early winter of 1921 and the summer of 1922, Traquair had the pleasure of spending time with the Manners at Avon Tyrell, their rural Arts and Crafts home designed and furnished by W.R. Lethaby.

This mural commission, effectively Traquair's swansong, reassembled key ideas. As at the Song School, she illustrated a religious text in terms of portraiture [61]. Her text, again a song of praise and belief, was the *Te Deum Laudamus*. As she wrote to her sister Amelia in Ireland

> it is not an allegory but the 'Te Deum' [which] you see to me [means] every beautiful and every fine thing, whether it be simple beauty as of a flower or a great deed as Pasteur, or a mother with her baby or a poet, all sing the Te Deum, tho' they often don't know it. So my composition includes John the Baptist, Tennyson, Blake, the Apostles, the Madonna, Lord Lister, Pasteur, workmen, soldiers and angels.

She aimed again at an equality of mankind, nature and the spirit. Set against the beautiful New Forest landscape, the figural groups also include St George and portraits of the living and recently deceased. Below the main scene she provides a gilded border. The upper decoration unites cultures: in the curved apse ceiling a Byzantine scene of Christ in majesty is attended by two pairs of Blakean angels all set against a gold ground while, lining the lower edge, portraits of local children look on, as in a Veronese painting.

The decoration is bonded by colour. She wrote to Amelia that

[61] Manners Chapel, All Saints Church, Thorney Hill 1920–2

In this last mural commission Traquair provided a composite image of a real and imaginary community. The main group includes figures regarded as important by patron and artist: the apostles, Tennyson, Blake, John the Baptist, Pasteur and Lord Lister.

ARTS AND CRAFTS

'it looks well. The run of colour is goldy browns, rose, cream whites and spots of olive green, and blue.' Music, which had meant so much to Traquair, also filled the chapel. She wrote of her figures, 'a lot have their mouths open. A lady who trains a small choir said she could nearly hear some of them.' Although this scheme marked the conclusion of a public career, Traquair, despite somewhat failing eyesight, continued to practice craft in her seventies as well as paint watercolours. Since the early 1890s she had travelled regularly to London and Paris, then to South Africa in 1895–6 and 1907 to visit a niece. She felt disappointment in her native Ireland where 'art of any kind is almost unknown . . . except amongst a very small circle'.

Like many women of her generation, Traquair rarely travelled alone outside the British Isles. In the 1890s her husband had accompanied her to South Africa. Following Dr Traquair's death in 1912 she enjoyed the company of Archibald Henry Sayce (1845–1933). Professor of Assyriology at Oxford until 1919, he had delivered both the Gifford and Rhind lecture series in Edinburgh during the 1900s. He was good company: in the 1920s the traveller Gertrude Bell wrote that 'for wits he is bad to beat'. Bell was less enthused by Mrs Traquair 'the elderly party', although she did acknowledge her as 'the most famous fresco painter of the age'. Traquair's thirst for knowledge and ideas was unabated. In the winter of 1913–14 with Sayce she toured India, returning via Egypt which they revisited in 1921. Their travels continued until at least 1928 when they wintered in Sicily and sailed the Mediterranean. While Sayce participated in archaeological excavations, Traquair, never at a loss, stitched her fabric, thus returning to her first craft embroidery. Domestic pieces such as her own bedcover recorded the date and each place name.

When Phoebe Anna Traquair died in Edinburgh on 4 August 1936, James Caw wrote for *The Times* of the 'Mural Painting and Art Craftsmanship' by this 'little woman ... sparely built but overflowing with nervous energy'. In her will she bequeathed to the Scottish National Gallery a number of key artworks – studies for the first hospital chapel and even a section of demolished wall, complete with bricks attached to the back of the plaster. With these came painted pages of the *Psalms of David* and *Sonnets from the Portuguese*, and a painted triptych of *Motherhood*, the last set with her own enamels in a copper frame. These were personal works she had kept by her through hard and good times. She also left to the nation her great hymn to life, *The Progress of a Soul*.

Traquair was part of a creative, socially responsible family who turned to the arts or medicine as their calling. Her elder son Ramsay became McDonald Professor of Architecture at McGill University, Montreal, in 1914 while Harry was an eminent ophthalmic surgeon in Edinburgh. Her daughter Hilda Napier, a skilled embroiderer, settled in British Columbia. A Moss niece, Beatrice Elvery Campbell, Lady Glenavy, was a leading ceramic artist in Dublin and London: in the mid-1970s her son, the writer and broadcaster Patrick Campbell, would recall his 'Aunt Annie' as a lady curiously devoted to her art.

Traquair was perhaps intellectually closest to her nephew, Willie Moss. Having edited The Rugby Miscellany and, while still a schoolboy, published Saga and Song on Japanese vellum in an edition of fifty, as an adult he would build up a fine library strong in the books and manuscripts of William Blake, even acquiring the poet's spectacles. He also purchased French, English and Persian manuscripts and finely printed Arts and Crafts books. He kept the letters Traquair wrote to him, and in 1955 these, together with archival photographs and her illuminations Sonnets from the Portuguese and The House of Life inherited from his father, were presented to the National Library of Scotland by his widow. They form a unique record of the life of Phoebe Anna Traquair. In her memory Willie Moss gave a sixteenth-century bell cast by Peter van den Ghein to the Iona Community. Today the bell 'Anna' is a reminder of how much the interwoven worlds of music, nature and the spirit meant to a Celtic artist.

Further Reading

Margaret Armour, 'Beautiful Modern Manuscripts', *The Studio* special winter number, 1897, pp.47–55

Gerard Baldwin Brown, 'Some Recent Efforts in Mural Decoration', *The Scottish Art Review*, January 1889, pp.225–8

G.F. Barbour, *The Life of Alexander Whyte D.D.*, London, 1923

Anthea Callen, *Angel in the Studio: Women in the Arts and Crafts Movement 1870–1914*, London, 1979

Lord Carmichael of Skirling: A Memoir Prepared by his Wife, London, 1929

James L. Caw, 'The Artwork of Mrs Traquair', *The Art Journal*, 1898, pp.143–8

Walter Crane, *Of the Decorative Illustration of Books Old and New*, London, 1896

Elizabeth Cumming, *Phoebe Anna Traquair 1852–1936*, Edinburgh, 1993

Elizabeth Cumming, *The Arts and Crafts Movement in Edinburgh 1880–1930*, Edinburgh, 1985

Elizabeth Cumming, 'Patterns of Life: the art and design of Phoebe Anna Traquair and Mary Seton Watts' in Bridget Elliott and Janice Helland (eds.), *Women Artists and the Decorative Arts 1880–1935: the gender of ornament*, London, 2002, pp.15–34

Elizabeth Cumming, 'Life's Rich Tapestry: Phoebe Anna Traquair's *The Progress of a Soul*', *The Review of Scottish Culture* 19, Edinburgh, 2007, pp.63–76

Elizabeth Cumming and Wendy Kaplan, *The Arts and Crafts Movement*, London and New York, 1991

Henry H. Cunynghame C.B., *European Enamels*, London, 1906

Alexander Fisher, *The Art of Enamelling on Metal*, London, 1906

Peter Floud *et al.*, *Victorian and Edwardian Decorative Arts*, London, 1952

Nicola Gordon Bowe and Elizabeth Cumming, *The Arts and Crafts Movements in Dublin and Edinburgh 1885–1925*, Dublin, 1998

John Miller Gray: Memoir and Remains, Edinburgh, 1895

The Knights of the Most Noble and Most Ancient Order of the Thistle. A historical Sketch of the Order by the Lord Lyon King of Arms and a Descriptive Sketch of Their Chapel Design by John Warrack, Edinburgh, 1911

M.L.M. (Margaret L. Macdonald), 'Edinburgh Studio-Talk', *The Studio*, vol.12, 1898, pp.189–191

Stuart Matthew, *The Knights & Chapel of The Most Ancient and Most Noble Order of the Thistle: A Panoramic View*, Edinburgh, 1988

A.F. Morris, 'A Versatile Art Worker: Mrs Traquair', *The Studio*, vol.34, 1905, pp.339–45

'The Mural Decoration of the Song School, Edinburgh Cathedral', *The Journal of Decorative Art*, May 1892, supplement, p.33

Peter Savage, *Lorimer and the Edinburgh Craft Designers*, Edinburgh, 1980

'Scottish Arts and Crafts', *The Art Journal*, 1907, pp.233–40

'A Scottish Lady Decorator: Mrs Traquair', *The Scots Pictorial*, 7 May 1898, p.10

Sotheby & Co., *Catalogue of the Very Well-known and Valuable Library, the Property of Lt.-Col. W.E. Moss of the Manor House, Sonning-on-Thames, Berks., who is Changing his Residence*, London, 2–9 March 1937

D.M. Sutherland, 'The Guild of Women-Binders', *The Magazine of Art*, 1899, pp.420–3

Ainslie C. Waller, 'The Guild of Women-Binders', *The Private Library*, 3rd series, vol.6: 3, autumn 1983, pp.99–130

Lawrence Weaver, 'Lympne Castle, Kent, the Seat of F.J. Tennant', *Country Life*, vol.28, 12 November 1910

Esther Wood, 'British Tooled Bookbindings and their Designers', *Modern Bookbindings and their Designers: The Studio*, special winter number 1899–1900, 1899, pp.38–47